MY WAY WITH WATERCOLOR
...a three-value approach

MY WAY

WITH WATERCOLOR

...a three-value approach

by Claude Croney

PUBLISHED BY NORTH LIGHT PUBLISHERS / WESTPORT, CONN.
DISTRIBUTED BY WATSON-GUPTILL PUBLICATIONS / NEW YORK

Published by NORTH LIGHT PUBLISHERS, a division of
FLETCHER ART SERVICES, INC., 37 Franklin Street,
Westport, Conn. 06880.

Distributed by WATSON-GUPTILL PUBLICATIONS,
a division of BILLBOARD PUBLICATIONS, Inc.,
1515 Broadway, N.Y.C., N.Y. 10036.

Manufactured in U.S.A.
First Printing 1973

Library of Congress Catalog Card Number 73-76261
ISBN 0-8230 - 3151 - 9

Edited by Howard Munce
Designed by Henry McIver
Composed in ten point Palatino by John W. Shields, Inc.
Printed by Kingsport Press
Bound by The Haddon Craftsmen, Inc.

I dedicate this book to
My wife Frances
My daughters Michaela and Nicole
My mother Lillian and father Claude D.
all of whom helped make this book possible,
directly and indirectly.
C. C.

CONTENTS

LIST OF PAINTINGS

PICTURE CREDITS:
Reproductions on pages 87, 94, 96, 98, 100, 102, 104, 106, 108, 110
Courtesy of The HARTFORD INSURANCE GROUP

Reproductions on pages 81, 84, 88, 91, 98
Courtesy of WATSON-GUPTILL PUBLICATIONS

Reproduction on page 83
Courtesy of FAMOUS ARTISTS SCHOOLS

INTRODUCTION

DURING the years prior to the turn of the century the art of watercolor was considered the polite accomplishment of young, and no-longer-young, ladies. The pictures they produced were sweet, pretty imitations of the 19th century English painters who had followed in the wake of J. M. W. Turner and John Constable. It's a pity the ladies chose to imitate the weaker members of that school, because it spread abroad the notion that British watercolor was a pallid approach to art taught by "Drawing Masters."

This, of course, was not true as anyone visiting the splendid exhibition of the Mr. and Mrs. Paul Mellon collection held in New York at the Pierpont Morgan Library during the summer of 1972, will agree.

The great names of that school such as Turner, Richard Bonington, Thomas Girtin, David Cox and John Sell Cotman, were the men who influenced the Americans and certainly helped give birth to what is now the strongest school of watercolor that has ever existed anywhere.

Two Americans, Winslow Homer, a New England Yankee, and John Singer Sargent, the sophisticated cosmopolite, did much to establish the American School. Both of these men in their time were best known for their oil paintings. Each are on record, however, as believing that their best work was to be found in the watercolors they produced during the final years of their lives. American watercolor has grown since with men like William Hopper, Charles Prendergast, Tom Nicholas, Andrew Wyeth and Claude Croney, who is the subject of this book.

Croney is strictly in the American tradition. The main stream of American Art has always been realism. More and more serious students are seeking teachers who can teach them to draw and paint the visual world. I have known Croney for several years and admire the man as well as his bold, direct approach to the watercolor medium. He comes right to the point, which is a good thing in any story teller.

His pictures are often limited in color, but colorful nevertheless, and always have that bold spontaneity that every good watercolor should have.

I'm sure that this book of his work will be an inspiration to anyone interested in improving their knowledge of the art of watercolor painting.

I'm honored to have been asked to write this small tribute to Claude Croney, a fine painter in the American tradition and a very fine person.

John C. Pellew, N.A. A.W.S.
Norwalk, Conn. 1973

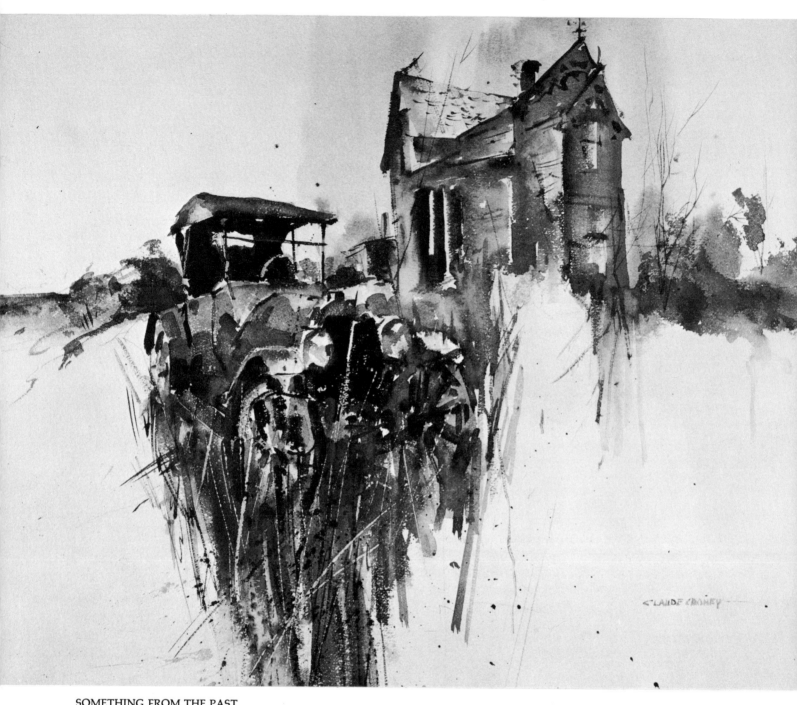

SOMETHING FROM THE PAST

Collection of Mr. and Mrs. Larry Smally

MATERIALS

FROM the beginning, one should consider his art materials as another craftsman regards his tool kit.

If you use the best, you'll find that they not only give the best results, but they also do not fight you. Picture-making has enough uninvited gremlins involved without seeking outside help. This is especially true of brushes for the watercolorist. An unruly brush can not only ruin a passage — but it can drive you as mad as a bent cue might make a billiard player. It's better to spend your money and save your sanity.

Pure red sable is the best kind of brush — either round or flat.

One of the criteria to use when you make your selection is that the brush have spring and bounce both before and after it has its load of water. If it doesn't regain its shape immediately after it's made its stroke — put it back. Beware of the bad ones that retain an L shape when the water's out.

These are the ones I use and recommend: A number 5 sable — this is a small one that holds a point and is used for small lines and accents. The next size is a number 12 round sable. I also use a flat 1½ inch sable that I had made to order. Long ago I promised myself the best brush I could buy when I became famous — then I decided not to wait and had it made anyway. It's my pride and joy! You can buy one almost like it — the number "X". I also use a two and a one inch varnish brush. These are flat and can be bought in a regular paint store. They're excellent for large areas. I also carry a number 4 bristle brush. These are really for oil but they are fine for softening sharp edges in watercolor.

Now I hasten to advise you to experiment with other brushes of all sizes until you find what fits your mood and style best. Eventually, you'll whittle your choice down to relatively few as I have.

Paper and paint are the next items to consider — and you'll eventually want the best quality in these too. But in the very beginning while you are following the exercises there is no reason to waste expensive paper.

To start, I recommend Strathmore Student. Soon, you can graduate to the excellent other grades of Strathmore or Fabriano or D'Arches such as I use. The latter's 300 lb. rough is my favorite.

Many painters prefer a smoother stock because washes flow with greater ease. I lean to the rough texture because it allows certain painterly effects such as scumbling and dry brush.

Watercolor papers vary in weight and whiteness. A full sheet is 22" x 30". The heavier weights resist buckling and take more abuse. Here again you'll find your favorite with a little experimentation.

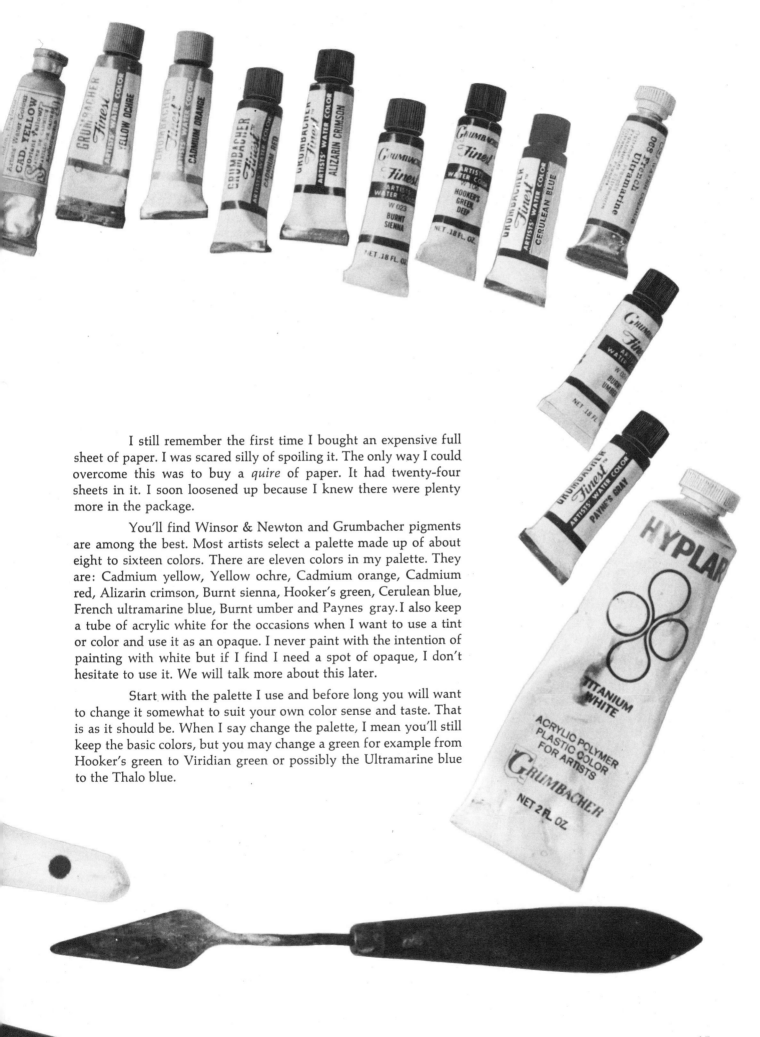

I still remember the first time I bought an expensive full sheet of paper. I was scared silly of spoiling it. The only way I could overcome this was to buy a *quire* of paper. It had twenty-four sheets in it. I soon loosened up because I knew there were plenty more in the package.

You'll find Winsor & Newton and Grumbacher pigments are among the best. Most artists select a palette made up of about eight to sixteen colors. There are eleven colors in my palette. They are: Cadmium yellow, Yellow ochre, Cadmium orange, Cadmium red, Alizarin crimson, Burnt sienna, Hooker's green, Cerulean blue, French ultramarine blue, Burnt umber and Paynes gray. I also keep a tube of acrylic white for the occasions when I want to use a tint or color and use it as an opaque. I never paint with the intention of painting with white but if I find I need a spot of opaque, I don't hesitate to use it. We will talk more about this later.

Start with the palette I use and before long you will want to change it somewhat to suit your own color sense and taste. That is as it should be. When I say change the palette, I mean you'll still keep the basic colors, but you may change a green for example from Hooker's green to Viridian green or possibly the Ultramarine blue to the Thalo blue.

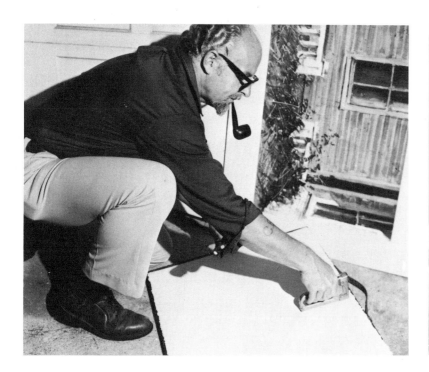

A strip of leather tacked to the edge provides a convenient handle and an easy way to carry the cumbersome drawing board.

There are two methods of mounting watercolor paper to a drawing board: dry and wet. Before mounting your paper you have to consider its size and weight. I use the dry method since my paper is usually three hundred pound weight — very heavy. If you use a thinner paper and are working small you can also use the dry method. However, I suggest using the wet method for up to about a hundred forty pound — full sheet size, which is 22" x 30".

Let's talk about the dry method first. You can simply use thumb tacks to fasten the paper to the drawing board. Masking tape is another method: tape the paper on all four sides letting half of the tape cover the paper and the other half the drawing board. With the three hundred pound D'Arches, I simply staple it to the drawing board. I start from the center of the four sides and gradually work out to the corners. Use about 16 staples.

Now the wet way. To mount the paper this way, wet both sides thoroughly. I usually place the sheet in a shallow pool in the bath tub, then lay it on a wet wooden drawing board an inch or so larger than the paper. When the edges begin to wrinkle, press down with your hand and glue all four edges to the board with shipping tape. It is sometimes called brown gum tape, the kind used in shipping departments. Years ago I used to place the drawing board behind the hot iron stove in the kitchen but I soon learned that was too drastic. Dry the paper in a normally warm place or it will tear away from the tape and cause you grief.

After you've finished your painting, trim around the outside edge with a razor. The mat should then be cut to a size to cover the thin band of tape that is now a part of the paper.

16

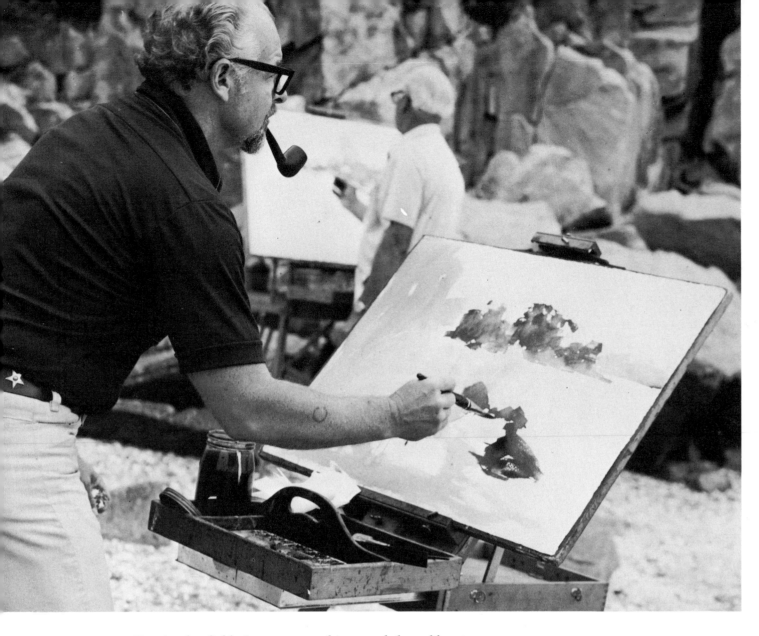

Out in the field, I want everything needed readily at hand, so no problems of equipment or materials will interfere with concentrating on the painting itself.

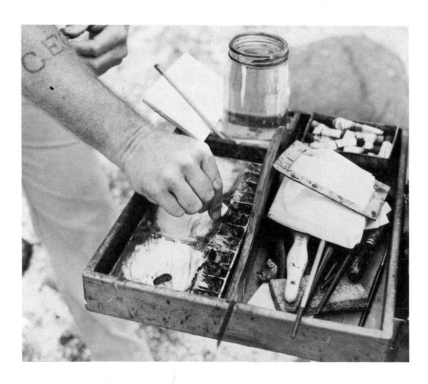

So much for the basic preparation — now to flesh out your list completely:

You'll need a drawing board on which to attach your paper and some 2B pencils, thumb tacks, staples, rags and a container to carry your water. I use an unbreakable plastic jar because it has a large mouth and holds about a quart. You'll also need a sponge, razor blades and a kneaded eraser. Also, facial tissues are important. I never go without them. They come in handy for blotting or wiping washes that get out of control, or blotting a dark that comes up too dark when applied to the paper. You simply wet and blot an area to lighten it. A regular oil painting knife is also part of my material. If you can obtain one, a butcher's tray makes an ideal palette.

A watercolor easel — here shown folded up — can be carried easily, along with a folding stool. For many years I carried my paints and brushes in an old shoe box for want of something better. Now I use a wooden box with a home-made handle. I find this much more convenient when I go out in the field to paint. I can carry everything in one trip. Save your time and temper for the picture — you'll need both.

In your kit, you should also have a small sketch pad, which you'll use for your preliminary sketches before you work on the painting. A mat with a small opening that you can hold in front of you as you paint the landscape is also helpful because it helps you frame your subject and exclude other disturbing elements.

Now you're ready to tackle the world — or at least that tiny part of it that appeals to you on any given day.

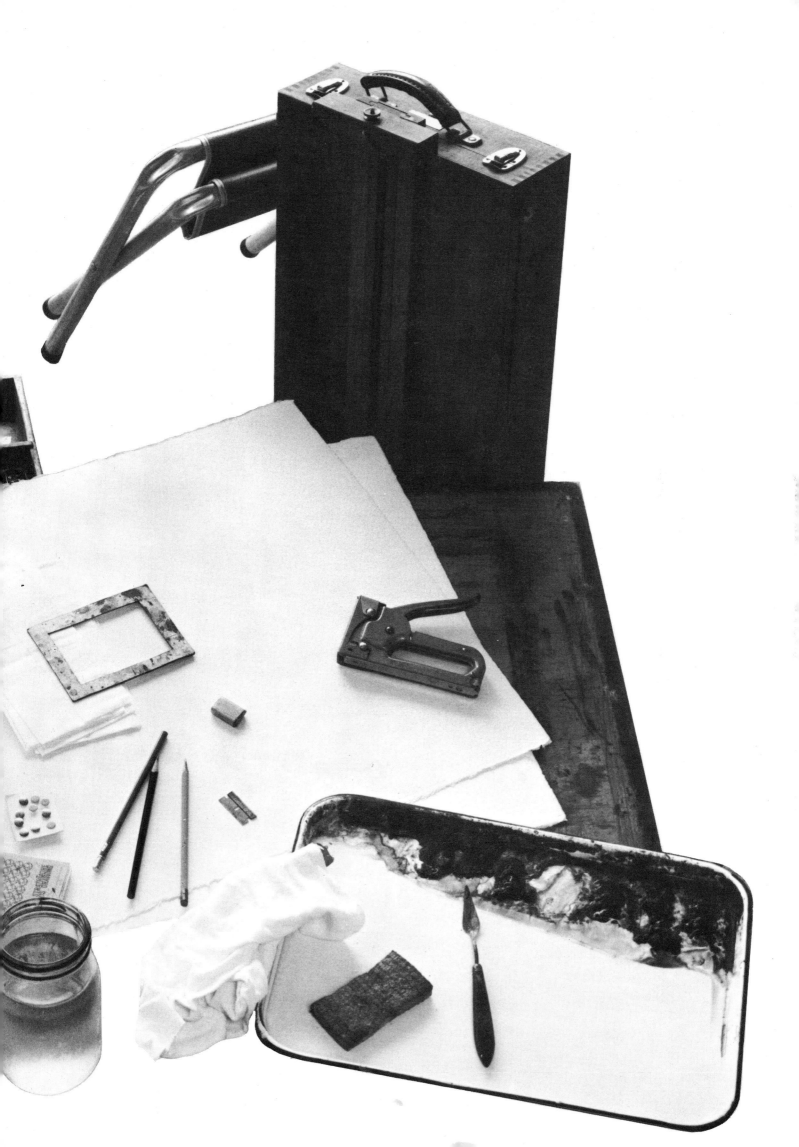

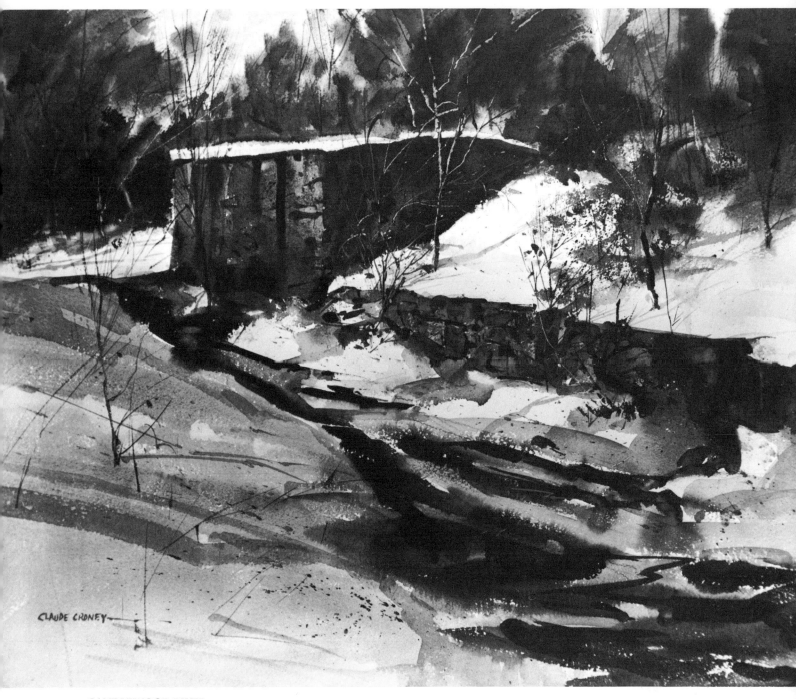

CANDLEWOOD RIVER

USING THE MEDIUM

BEFORE we learn better, most of us waste a great deal of time and go through disheartening periods of depression, searching for magic methods and easy ways to picture-making.

Mostly we erroneously think in terms of tricky techniques and flashy capers.

The watercolorist above all other painters needs to speak through *interpretive* techniques — sensitively felt ones that give the *illusion* of nature.

For it's only when it's *your* interpretation and not just a slavish copy of nature that one's self begins to show.

I will show you 12 examples of how I've learned to interpret certain moments in nature.

These are very personal to me. But if you will practice them — only as a way to begin — you will soon see *yourself* coming through and looking more like *you* than me.

In practicing these techniques it's only necessary to use one color. Make that burnt umber. Squeeze some onto a pallette or tray. Pick up some water with your brush and put it on the tray where you're going to mix your tone. Then with the tip of the brush pick up some paint and mix it with the water. Now, follow me step by step.

1. Here, I've made three values with simple washes. First I used very little water and lots of pigment. This gives you a very dark value. Now add a little more water with the tone and make a middle value. Still more water and of course we make a still lighter value — simple as that!

I'll discuss the importance of value *relationships* in the next chapter. But for now we'll concentrate on creating different textures and effects.

A.

B.

C.

A.

B.

C.

2. These three blocks show the wet-on-wet technique. In Block **A** I washed on a dark tone of color. Then before the paint dried, I painted in a still darker tone. In Block **B** I used a lighter background wash, and while it was still wet, I painted in the darker tone. In Block **C** I used a clear wash of water, then painted a tone that is not as dark as the others. Notice how I've tried to control the overall value effect of each of these. When you use this wet-on-wet technique, paint the darker tone into the lighter one.

A.

B.

C.

3. These are drybrush techniques. You simply pick up paint as you did before and blot out some of the excess. Then lightly drag the brush over the paper. The paint *and* the rough paper create the texture. The paint just hits the raised surfaces of the rough paper. This is also a good place to control the value of your drybrush technique. Try using a dark drybrush, a middle tone and a light drybrush. This practice will be invaluable.

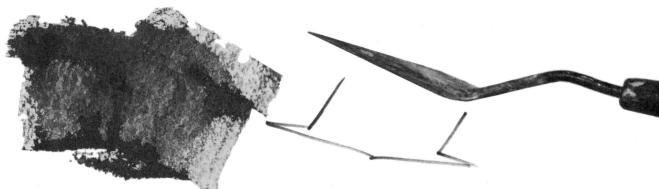

4. With this technique I paint the area the value I want and while it is still damp, I use the side of a painting knife and squeegee the paint in whatever direction I want. This texture of course will be rough because the area where you squeegee takes the paint off the top peaks of the paper. This technique works best when using a coarsely textured paper as I did here.

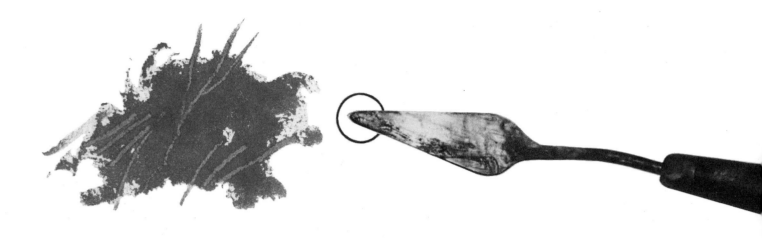

5. You can also scrape out the light with the tip of the painting knife while the paint is still damp.

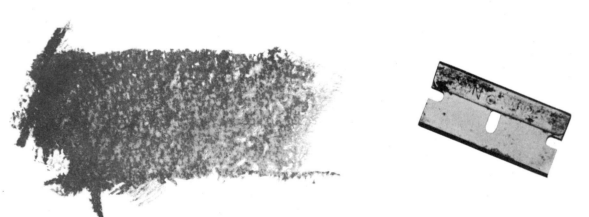

6. This is a technique to use after the paint dries. You can scrape and shave a light rough texture by carefully using a single edge razor blade. Here again the rough paper helps to make this work more effectively.

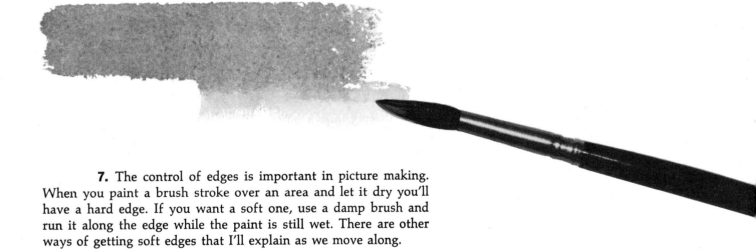

7. The control of edges is important in picture making. When you paint a brush stroke over an area and let it dry you'll have a hard edge. If you want a soft one, use a damp brush and run it along the edge while the paint is still wet. There are other ways of getting soft edges that I'll explain as we move along.

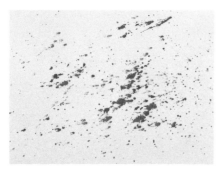

A.

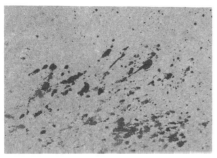

B.

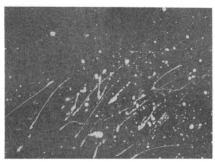

C.

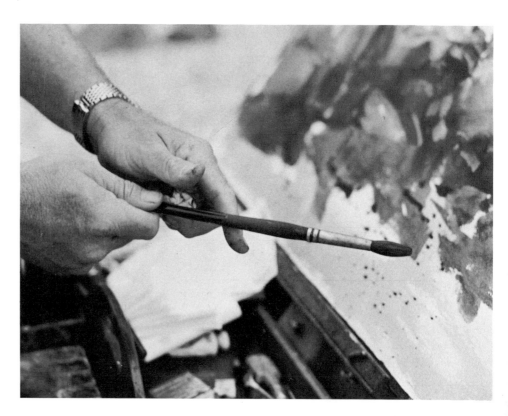

8. I often use spatter tone. The way this works is that you first load the brush with paint — the value you want — then aim it over the area where you want the spots to go. Then gently tap the brush against your hand or another brush handle and the result will be spots and specks. This gives you an added technique and texture that you can't get any other way. In Block **B** you can see how I combined it by using a method of a dark spatter over a light tone. Block **C** is just the reverse — light spatter over a dark tone. Add some white acrylic to your paint for an opaque quality that will cover the dark undertones.

9.

9. This diagram shows you how you can get a soft edge another way. In this I've let the paint dry then I came back with a wet bristle brush along the edge and blotted with a tissue. The reason I'm stressing edges is that many times after I've finished a painting and put it in a frame and lived with it a while I've noticed that there is an edge that is a bit disturbing. Maybe it's an edge in the background that I feel is too important and that is attracting too much attention. When I spot one, I take it down and perform this simple repair.

10. Here is a way to get a soft edge while the painting is in process; by painting one wet area next to another wet area the edges will blur and run together. With this you have to be careful and use greater control, because if the areas are too wet they will get lost when they meet. If the first tone is too dry when you paint the second one next to it the edge will be too hard. There has to be just right amount of dampness to make the edge soft but still noticeable.

11. This is another way to lift the light out of a darker area. Use a pointed sable brush or a bristle brush. Dampen the brush then scrub the area and blot it with a tissue. I usually do this when the area that I want to lift is small.

12. There will be times when you are painting some small details or even a wash and it will appear too dark. Don't panic. Just pick up a tissue and blot it. Quite often I use this technique deliberately when I'm painting details in the background or in areas that I want to appear light. It's often difficult to get a very light tone to register with enough strength. Then I put the tone down darker than I want it and blot it back to the tone I wanted originally.

10.

11.

12.

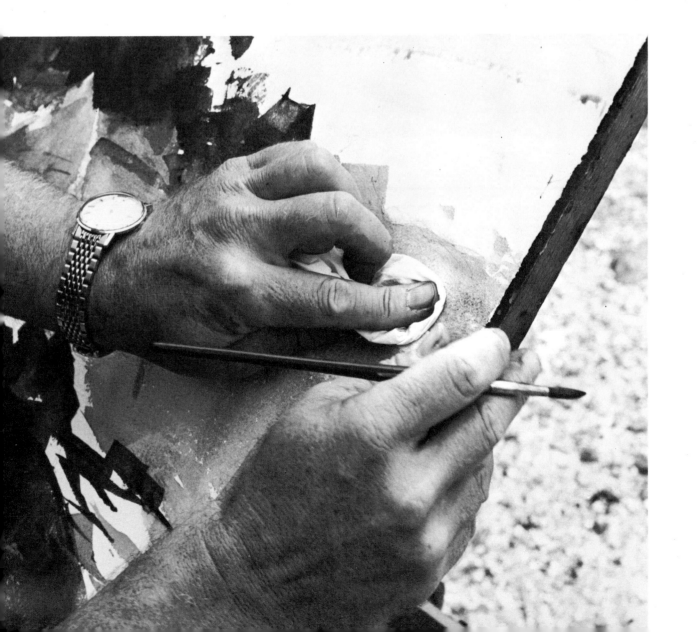

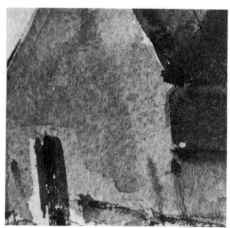

1.

These methods are all ones that I use in my paintings. This doesn't mean that I use every one of them in every picture. But I use a combination of these in creating the illusion of nature. Perhaps a close look at this picture I did for a painting demonstration for the Wyoming Valley Art Group in Wilkes-Barre, Pa. will best show you what I mean. Notice I've used the wet-on-wet technique for the sky, for the soft, smoky misty atmosphere. Then for the side of the building, I've employed a simple wash. In the trees in the upper right of the picture I scraped out some light suggesting light struck branches against the dark background. Some suggestion of light struck trees were handled in a softer manner. In the foreground grass as you come through the snow, I've used a combination of techniques. In other words, I painted in the light tones first then used some dark drybrush over it. Always in watercolor paint dark over light. I've used the spatter tone in number 6. Notice some of the dark rock formations in the foreground and how I've used **opaque spatter to introduce some light spots over a dark area of rock.**

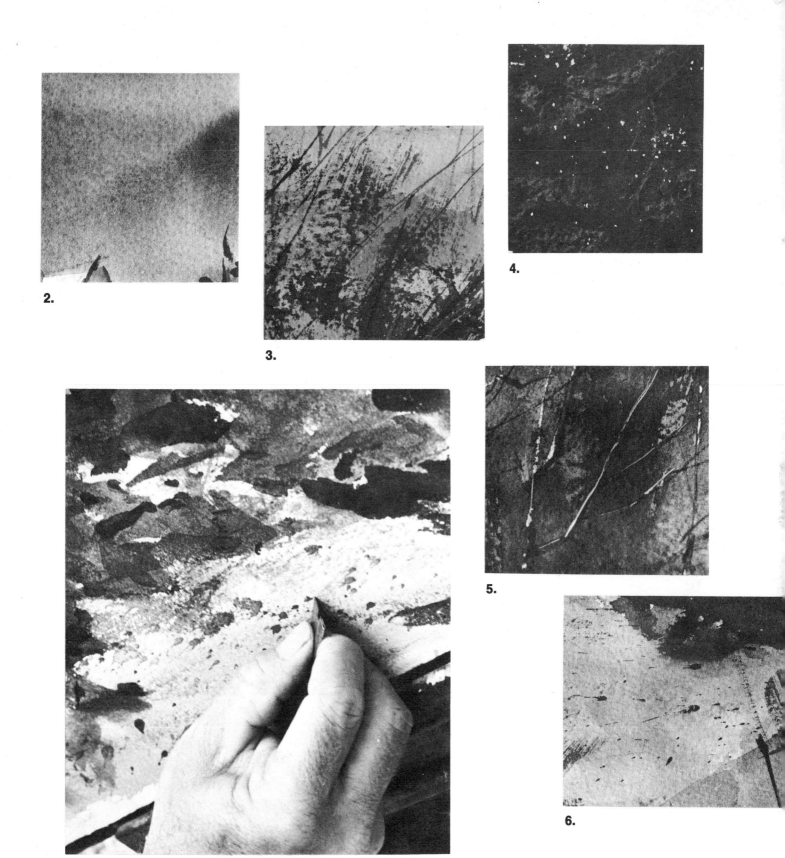

2.

3.

4.

5.

6.

A word of caution here, however. Each of the techniques employed has had a definite purpose — to represent a particular aspect of nature. Many beginners become so carried away by their preoccupation with special effects that they forget their primary reason for employing them — as a means of interpreting nature. Use these technical hints as honest tools not as empty gimmicks.

VALUE PATTERN

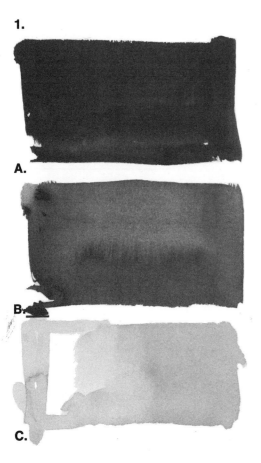

1.

A.

B.

C.

T HE word *VALUE,* which means the lightness or darkness of a color, is among the most important in an artist's vocabulary.

When you learn to observe *value* as you observe color, your life as a painter is on the right track.

Hopefully this chapter will set you right.

The foundation of every picture you'll be seeing in this book is based on only three values.

When you come to understand this, you'll be able to look past the techniques and razzle-dazzle of the surface to the underlying simplicity of the basic plan.

1. For our first exercise I want you to work only in burnt umber and copy my three values, **A. B. C.**

A. Do the dark patch first.

B. Do the light one next and allow a bit of

the white paper to show through.

C. Mix a tone that is halfway between the two.

Now let's relate these three values to nature, using them to suggest the illusion of a summer scene.

2. As you can see in my sketch I've divided the picture space into three parts: sky, trees and ground. The sky is usually the lightest value since it is the light *source.* The ground faces the sky as it is a horizontal plane. Hence, it will pick up much of the reflected light from the sky. That makes it a middle value. The trees are *vertical* planes so they receive less light and therefore become the darkest value.

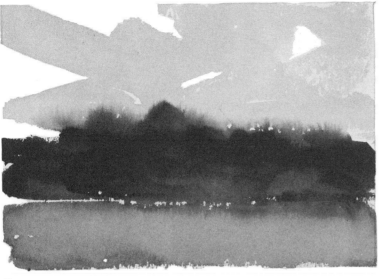

2.

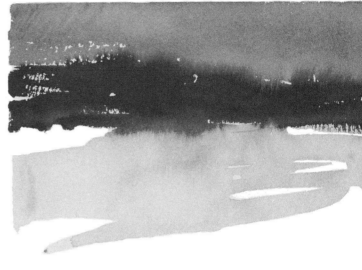

3.

3. Simple. Remember it forever! In the winter sketch I've made the same three divisions but now the ground is snow and it becomes the lightest value — the sky the middle one and the vertical trees remain the darkest.

Now turn them upside down and see the seasons change!

Please don't construe this simple demonstration to be a formula for every picture you'll ever make — it's not even the only way to do these two subjects.

I've attempted to cut this problem to the bone in the beginning so you can learn to look at nature and see what happens when a certain light source hits vertical and horizontal planes.

This is very important to learn at the start because you'll soon understand that to do a realistic impression of nature you must first be able to reduce a scene to its proper value relationships.

Take time out and practice what I've shown.

Work loosely and bravely with a fat brush. Don't skimp on color. Most beginners tend to be timid and work pale. You'll know when you've got a good one because you can squint your eye and it will look like a real scene when actually it is only an impression achieved by the proper combination of a simple light, dark and middle values. Magic!

Now if you're thinking to yourself that the world can't be made *that* simple let me remind you that these are only exercises to inculcate a basic understanding. When you get to actually making a watercolor, all sorts of other great things will happen — the very *nature* of watercolor is one of surprise and discovery and delight. And the very fact that you are *you* with your own particular talents and personality and handwriting and a sense of interpretation will make a special thing happen.

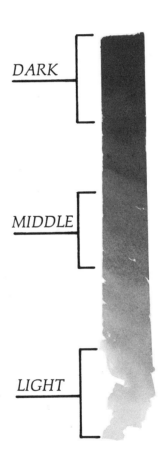

DARK

MIDDLE

LIGHT

Here is the gradual change in values from light to dark. In order to simplify and strengthen my pictures I use a pattern comprised of these three values.

The next three illustrations are random photos I've torn from the newspaper and reduced to light, dark and middle tones to demonstrate further what I've been saying.

Notice how I've simplified complicated areas. After I put in the big major shapes with the three tones, I used some techniques to lift out a simple extra light.

In **4.** I scraped out with a painting knife while the paint was still damp. When it dried I went over it with a little dark to put in an area over the middle tone.

4.

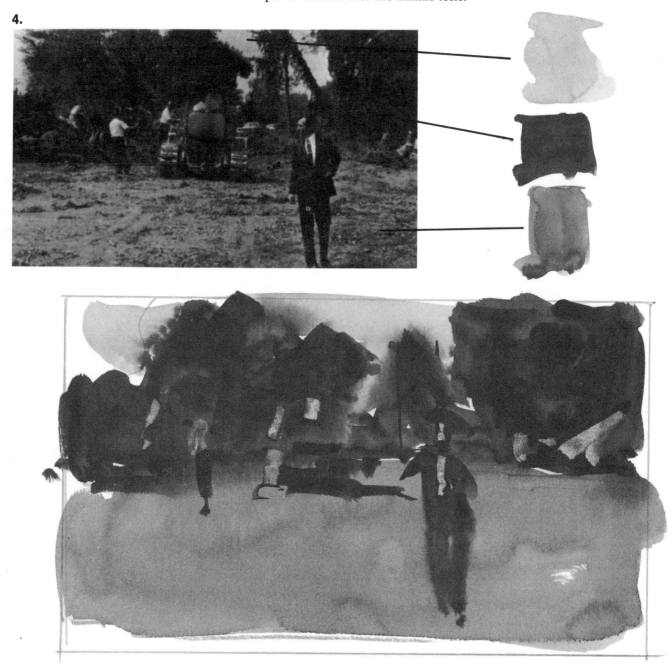

Photos Courtesy Danbury News-Times.

5.

5. When translating tones from the newspaper don't be concerned with details. Just try for the over-all illusion in a bold, simple manner.

6. In this value analysis, the sky and snow were part of the light with the sky being only slightly darker than the snow. I made the difference more obvious by using a middle tone for the sky and white paper for the snow. When you can, it's a good idea to take advantage of the white paper for some of your lightest values; it adds sparkle to a watercolor.

These are not paintings of course — first exercises, but I'm sure you can see the value of them (pun intended).

Try tearing out and painting a couple of news pictures every day. Do it for ten days. You'll be amazed!

Put your hat on. We're going to leave the studio and go outdoors where the real action is!

6.

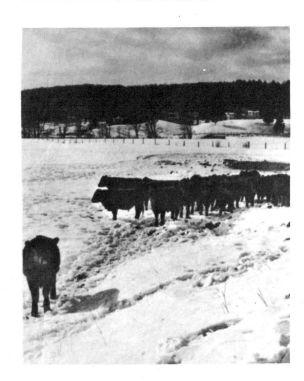

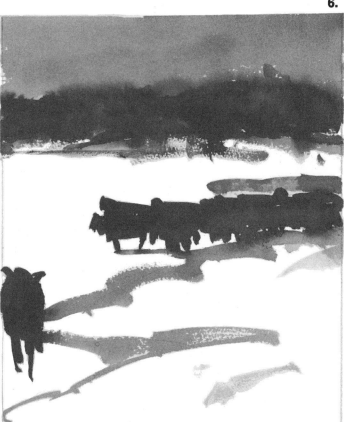

When I work out of doors, I usually use a pencil to make my quick value study before I tackle the watercolor painting. I do this for many reasons. First, it works out a lot of my problems of placement and design, remembering that design is probably one of the strongest elements in picture making. It also acts as a warm-up for my painting. The reason I use pencil is because it's easier to walk around and look at my subject at different angles carrying a small pad of paper and pencil. I use a 2B or 3B. It also conserves my clean water. When I'm ready to paint it won't be muddy from using the burnt umber. While I'm sizing up the subject I'm thinking of design, then I draw the subject on a small pad and using the three value approach again I quickly block in the major areas. To get the best use out of your pencil, get a piece of scrap paper and make the darkest dark that pencil will make. Now that that has established your dark, make a light tone and somewhere between the light and the dark, make a middle tone. It was sort of a gray day when I painted this picture. The trees appeared quite dark. The

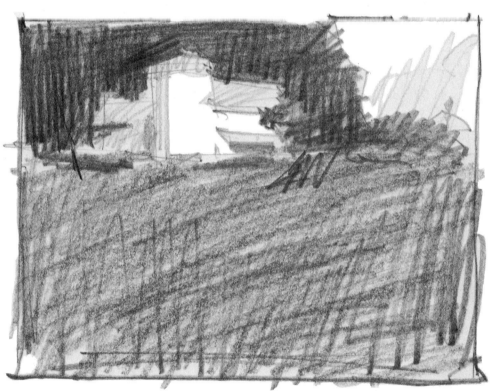

This sketch is reproduced at actual size. I find it an adequate scale at which to resolve the picture pattern.

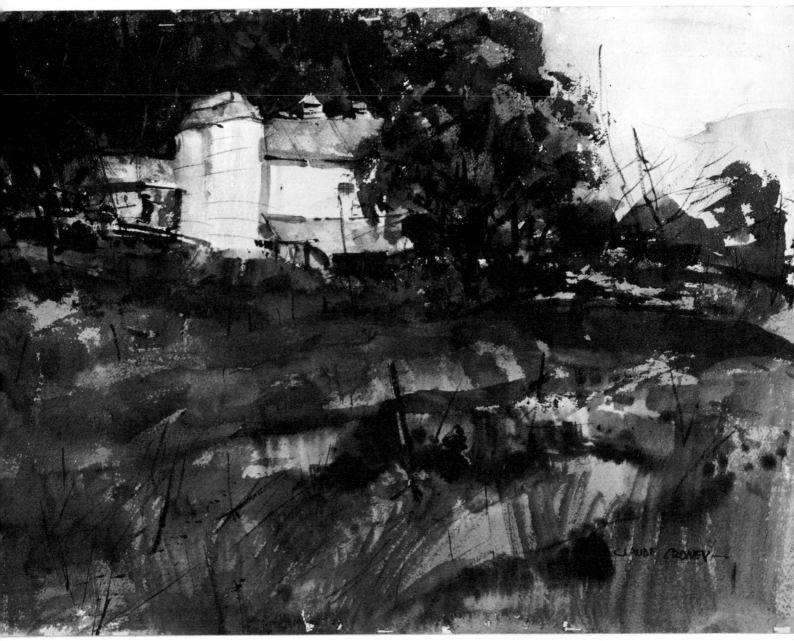

WHITE BARN

barn showed up as a light shape, and the sky was light. The grass was damp and worked into a good middle tone.

Make your value notes quick, simple and small. About four by five inches is a good size. No detail, just a strong visual impression.

Now we are ready to paint. Once the major value pattern is planned the rest of the painting will be relatively easy. Remember the value pattern. In the area that is dark, don't be afraid or timid. Paint it bold and dark. If an area should appear or dry lighter than you plan, and this is usually the case in watercolor, don't be afraid to go back and hit it again using lots of pigment. It is very important for those dark areas. You can see in my painting that after the big value pattern was established, I went back and worked over the areas for textures and a suggestion of detail.

Don't be fooled! A middle tone against white will look quite dark, but notice that it looks lighter against a dark background.

33

Sometimes one of these little doodles
from imagination can be turned into painting.

I keep a sketch pad next to my sofa and in between television programs I often do five or six small pencil value patterns in one night strictly from imagination. These little doodles are quite abstract at times. Other times I have a specific subject in mind. I'm primarily interested in dividing the picture space into interesting and varied shapes and sizes, so I simply block in areas of dark, light and middle tone values with a pencil.

Sometimes I'm lucky enough to have one turn out with possibilities to be developed into a painting. I wish I had a dollar for every one I've thrown away. But it's excellent practice. Here again I keep the sketches very small. When they are small, they keep you from getting involved in meaningless detail.

The painting on the right hand page happened strictly by accident. I was doing a painting demonstration for the Kent Art Association. I was brushing some of the excess paint off a large brush on some scrap paper I had handy for applying some dry brush texture to the painting. After I got home, I looked at it, and it created an interesting kind of design. This was because of its strong dark and light pattern. The white paper of course being the light. The variety of shapes created something of a design, and I could imagine some heavy cliffs with snow. On the same piece of paper I added some middle tones using it for the sky and some areas of the snow. Then with a small brush, a #5 pointed sable, I brushed in a few thin lines suggesting trees. After this was done, I painted a full sheet of watercolor from it. Now, what really happened here was a simple accident of dark and light and I added the middle tone. It struck me as having possibilities so I made a larger painting from it.

One thing I'd like to caution you about doing a larger painting from a small sketch or even from a small painting; don't be trapped by making an enlargement.

Watercolor painting is exciting and you should strive to keep some of that verve and spontaneity in the larger painting. Try to make the large painting work for itself, not just be a copy of the small original idea.

I haven't talked about color yet, but once the value pattern is established, you simply relate the color to the values. This you will see as we move into the demonstrations.

The paper I mostly use for these value studies is 140 lb. Fabriano, medium surface. I also sometimes use a smooth drawing texture. As I said before, these are not finished paintings. I prefer to use burnt umber, but you might favor black or Paynes gray. Use a brush that is big enough to keep you from fussing with detail for the major area. A #8 red sable is good. Then, if you wish, a #5 to simply suggest a few accents when needed.

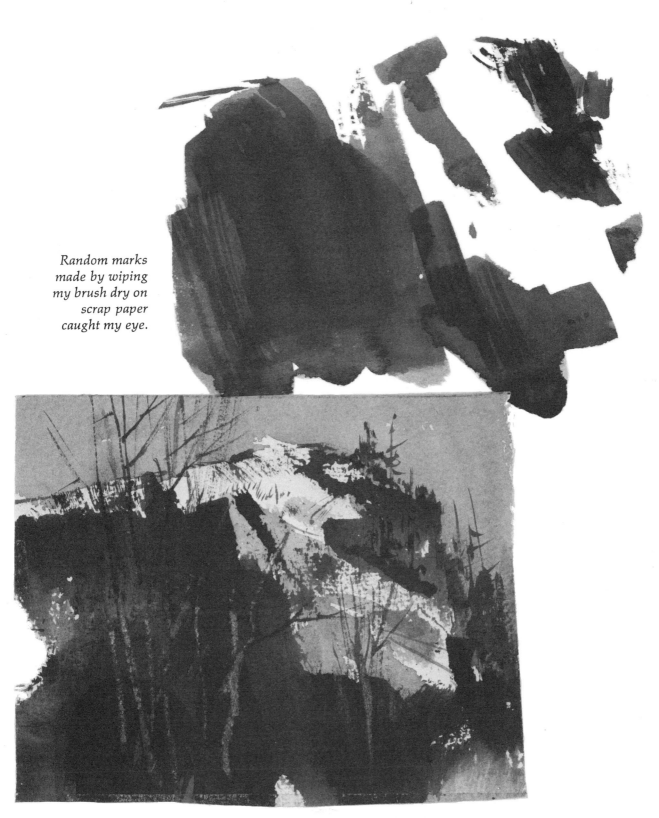

Random marks made by wiping my brush dry on scrap paper caught my eye.

The addition of middle tone created a sky and a few lines suggested trees. The rest was easy. This was the original scrap of paper.

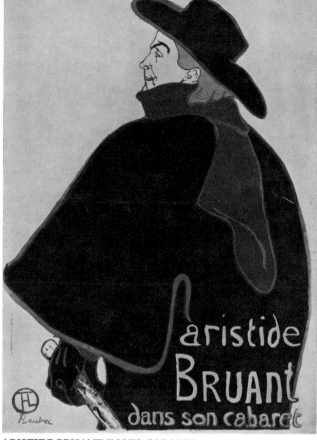

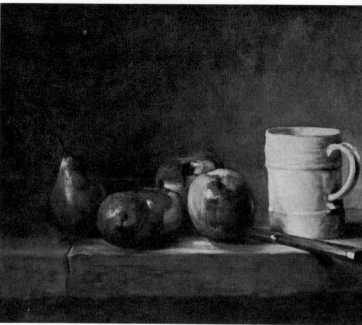

STILL LIFE: APPLES, PEAR, AND WHITE MUG
by JEAN-BAPTISTE-SIMEON CHARDIN
Gift of the W. Averell Harriman Foundation in
memory of Marie N. Harriman.
National Gallery of Art, Washington, D.C.

ARISTIDE BRUANT IN HIS CABARET
by HENRI de TOULOUSE-LAUTREC
The Metropolitan Museum of Art

Let's look at some paintings by several artists who work in very different styles and study how they constructed their particular pictures. These range from a flat poster-like approach to extremely detailed painting. I've made simple diagramatic value studies of these paintings to show how they relate to the *three value* approach. Let's start with the most obvious value pattern, a painting by Toulouse Lautrec, "Aristide Bruant in his Cabaret". Notice the strength and simplicity of this strong unified picture. The beautiful strong pattern is one of the reasons it works so well as a poster.

Chardin's still life, "Apples, Pear and White Mug" has not been treated as flat as Lautrec's poster, but see how it reduces into a simple dark and middle tone value pattern. Chardin wanted to brighten the still life so he illuminated it. To separate the light objects from the dark ground calls for some contrast, so he played the light against a dark background. A middle tone was then used for the front edge of the table top.

Whistler's "Arrangement in Grey and Black" goes into still more detail especially the women's features and hands — even the pictures on the wall. But let's simplify it and see how unimportant those details are, relative to the beautiful arrangement of shapes and of course, the

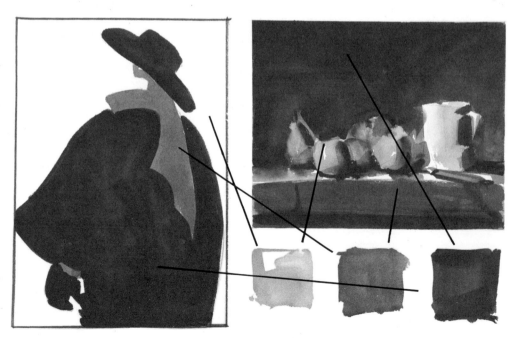

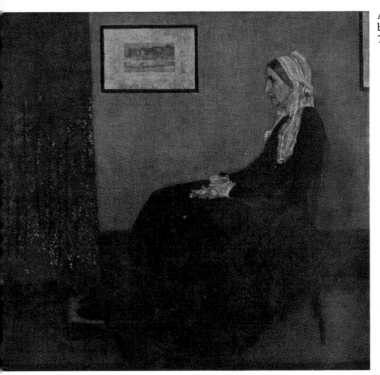

ARRANGEMENT IN GRAY AND BLACK NO. 1
by JAMES ABBOTT McNEILL WHISTLER
The Louvre Museum, Paris

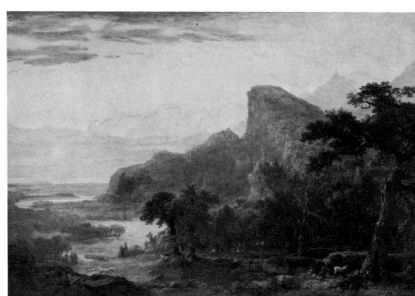

LANDSCAPE: SCENE FROM THANATOPSIS by ASHER B. DURAND
The Metropolitan Museum of Art: Gift of J. Pierpont Morgan, 1911.

strong unified value pattern. This is what you really see first when viewing it from some distance.

Asher Durand's "Imaginary Landscape". The artist here has more detail than any of the others we've looked at. But even with the detail, study the simple value pattern and see how value relationship was used to distinguish one major area from another. Here the use of dark in the foreground played against the middle tone helps to dramatize the illusion of distance. This is a fine example of the basic principle that lighter values appear to recede.

I've talked about strength and unity of value patterns, but the arrangement of shapes within the picture space (composition) are of course of extreme importance. I'll go more deeply into composition in the next chapter.

If you ever have the opportunity of watching an artist do a painting demonstration, stand way back and you will see that once he has the paper covered you quickly become conscious of pattern. From a distance the picture will not seem to change as he adds accents and details. It is only when you get closer that you appreciate the finished work. The big value pattern doesn't ever change. It is much more important than the amount of detail that is added.

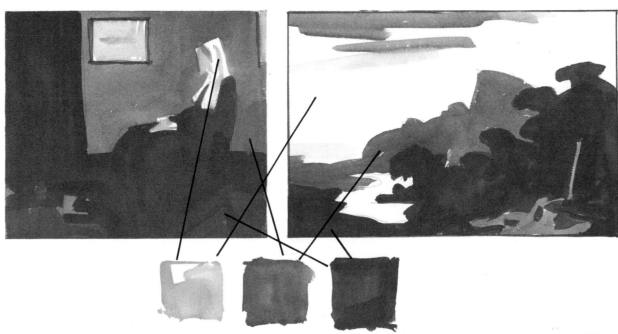

CHAPTER 4

COMPOSITION

COMPOSITION is probably the strongest single element in picture making. I've purposely kept these diagrams simple so that you would be less concerned with the picture or subject matter than the simple basic principles that I shall show you. Another way to define composition is to say that it is "happening" when one arranges flowers in a vase.

1. Let's use that rather mundane act as an example. Notice that the flowers are all equally spaced out and equally lined up. This arrangement is static and uninteresting, and hardly anyone would be content with it.

2. Now, immediate improvement when one of the flowers is raised. **3** Some pushed down, others moved over . . . still better. Normally one does this intuitively rather than intellectually.

1.

2.

3.

4. **5.** **6.**

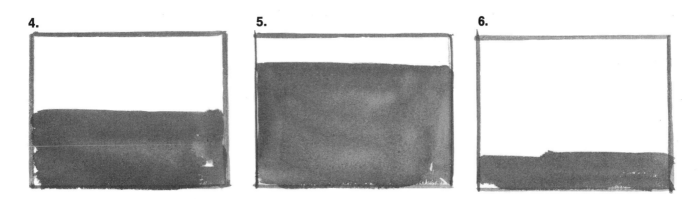

This deals with the division and subdivision of space. In **4** I've divided the picture space into two equal areas. This is valid, but dull. **5** and **6** are more exciting because they don't play it safe.

7. **8.** **9.**

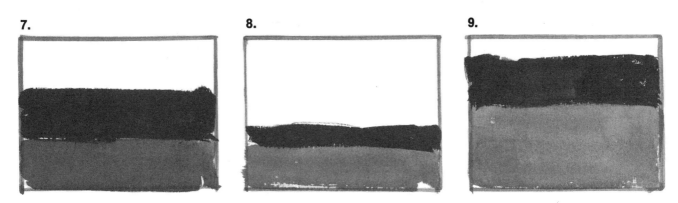

7 — now let's divide the picture space into three equal parts: light, dark and middle tones . . . still dull. **8** is more varied. I've placed the emphasis on the sky, and **9** on the ground area. This approach can readily be related to landscapes. But the principle is sound for any kind of design.

10. **11.**

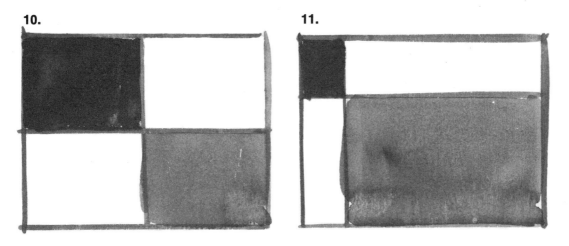

10 is again safe and dull. **11** is varied, lively and un-mechanical.

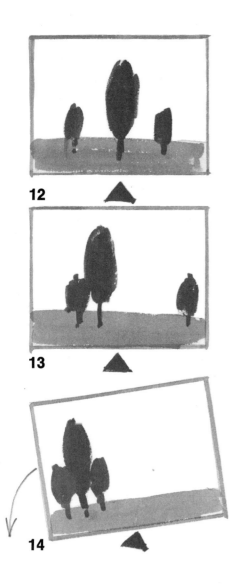

12

13

14

BALANCE In **12** we have a formal balance. Notice that one side of the picture is about the same size and shape as the other side. This is sometimes called symmetrical balance. A more exciting composition can be made with an informal or asymmetrical balance. Notice in **13** how the small tree closest to the border helps balance the two larger trees near the center. In **14** we have a composition that is off balance with all the weight to one side, making the picture appear to topple over.

MOVEMENT The eye usually enters the picture space from the bottom. Avoid a strong movement in line or shape that leads the eye right out of the picture space as in **15**. In **16** notice how the path swings around and leads the viewer's eye back into the picture. In **17** the natural shape of your paper created by the four corners can be a problem. Avoid any strong movement or line that leads into these corners. When possible, as in **18**, strengthen these corners. In **19** straight lines and shapes move quite fast through the picture space. When I refer to the speed of line or shape I mean how fast or slow the viewer's eye follows these lines or shapes. Notice how much slower your eye moves in **20**. None of these principles should be regarded as sacred. There will be times when you can successfully disregard them.

Always consider the size of your subject and what you want to say about it. In **21** I've placed the subject back in the distance. In **22** I've moved the subject more toward the middle

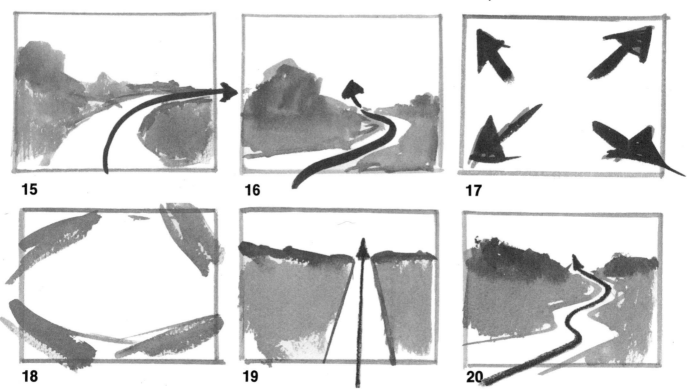

15 **16** **17**

18 **19** **20**

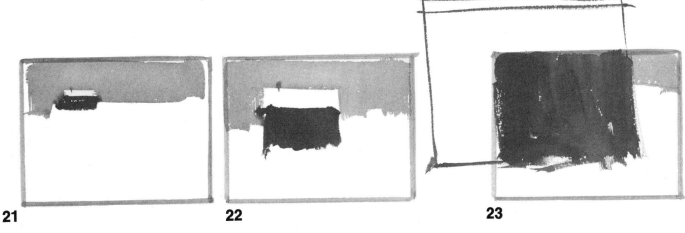

21 **22** **23**

distance. In **23** I've brought the subject very close to the foreground for a close-up, more detailed effect. Even using the same subject matter, notice how the proportions and major shapes change. The proportions of the light, dark and middle tones, (shapes in themselves), also change.

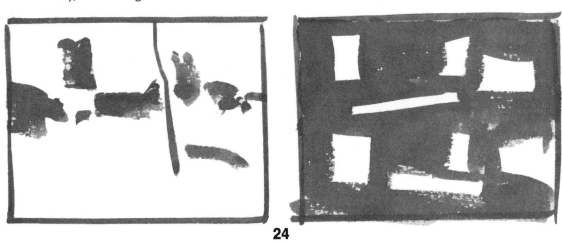

24

UNITY. In diagrams **24** I've placed isolated and separated dark shapes against light and vice versa. The designs in each case are spotty. It causes your eye to jump from one spot to another.

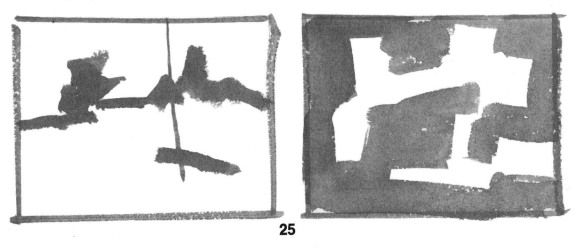

25

In **25** I've tied the elements together. Notice the stronger feeling of unity both designs have now. This doesn't mean that you have to tie every dark and every light together at all times, but the principle is sound.

26

Most landscapes or seascapes will fit more comfortably in a horizontal composition. This is because of the natural horizontal movement of the land and its directions. Look at the diagram vertical and horizontal. Notice that the strong horizontal in the vertical appears to run the eye from left to right through the picture space. And in the horizontal it carries the eye from bottom to top through the picture space **27**. Now study the other diagrams. It's usually a good idea to emphasize some strong vertical shape or movement in a vertical format. Notice the vertical shape of dark against light and the vertical shapes of light in the background. Note the natural movement of the darks in the horizontal. In this chapter on composition I've only touched on some of the basic principles, and I've tried to avoid telling you not to do certain things and only do others. What I want you to do is to think about these ideas and principles, use them to suit your specific needs, and in your own personal way.

When planning your compositions you will find it most helpful to simplify the shapes and values to the point of abstraction. This is true no matter in what style or how realistically you paint. You can then become more conscious and aware of the importance of shapes and the division and subdivision of space. And most important, how you, as an artist, can take the liberties of changing, elongating, moving, reducing or omitting a shape or shapes for an interesting visual effect.

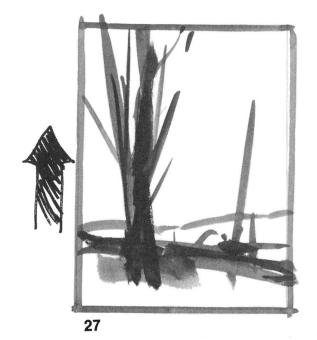

27

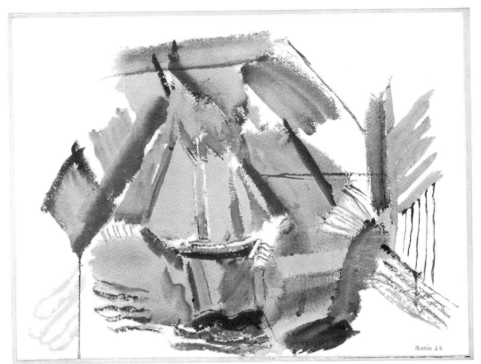

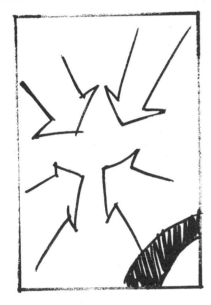

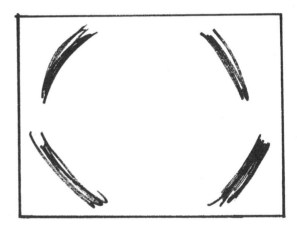

We'll now examine some well-known paintings and see how these illustrious artists applied some of the principles of composition.

"Ten Cents a Ride" by Louis Bouché. In this painting the artist used strong movement to guide the viewer's eye from the front of the picture space to the back, into the distant area where the figures are looking out into the water. These lines force the eye back into picture space so strongly that the artist added a white newspaper to slow down the movement; the newspaper also helps to straighten the corner of the picture space. Notice that there are no lines that stem directly from the corners. The movement comes from that general direction.

John Marin's "Boat off Deer Island". Here the artist used a bold spirited attack in his watercolor. Notice how he straightens the corners; this of course was done more obviously than the subtle manner that Louis Bouché used.

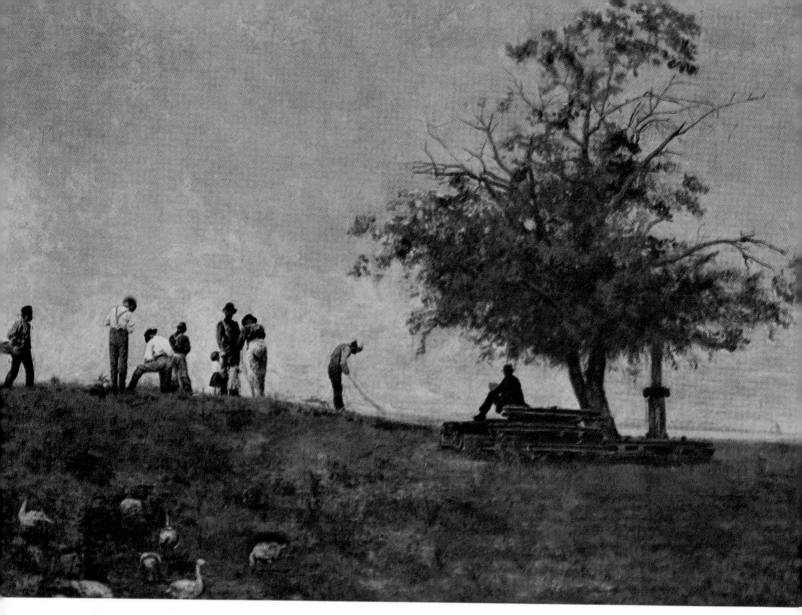

MENDING THE NET by THOMAS EAKINS
Philadelphia Museum of Art: Given by Mrs. Thomas Eakins and Miss Mary A. Williams

I've talked about balance . . . here's a fine example, "Mending the Net" by Eakins. Notice the shape of the large tree and the figure under the tree. This creates a tremendous amount of weight on the right hand side of the painting. He used figures moving out toward the left to help balance this. Notice the importance of the dark figure right near the border. Actually all of the figures acted as counter weights to balance the large shape on the right. You can see how the figures are varied by grouping and positions to add visual interest to the total design. They've served a dual purpose.

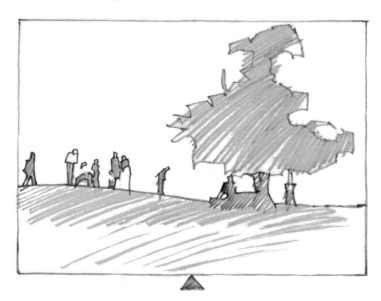

"Rhythm" by Mondrian. This is a totally abstract painting with no literal props or objects so it was imperative that careful thought was given to the variety of sizes and shapes and subtle balances. Look at the black lines and their arrangement. Study the space between the lines and the variety they give to these oblongs. Mondrian might have done this with all equal space between the black lines, but I'm sure you would agree that it would have become static and less exciting. Now look at the color he added and how he balanced the total effect. You'll notice that even the values play an important part. The large dark mass of blue **A** on the left is balanced by two spots of color on the right. The value in these areas do not have to be as dark to balance the large dark one. There is red-orange **B** on the extreme right; and, although it is very small, it carries considerable weight because of its position and the fact that it is a very bright warm color. It attracts more attention than the cool tone on the left. The yellow **C** is a very light value but seen together with red-orange, the middle tone, is just about right to achieve visual balance.

To summarize, two small spots on one side help to balance one large one on the other side. Small bright colors carry more weight than a larger more subdued color.

Composition is only *part* intellectual — mostly, it's intuitive.

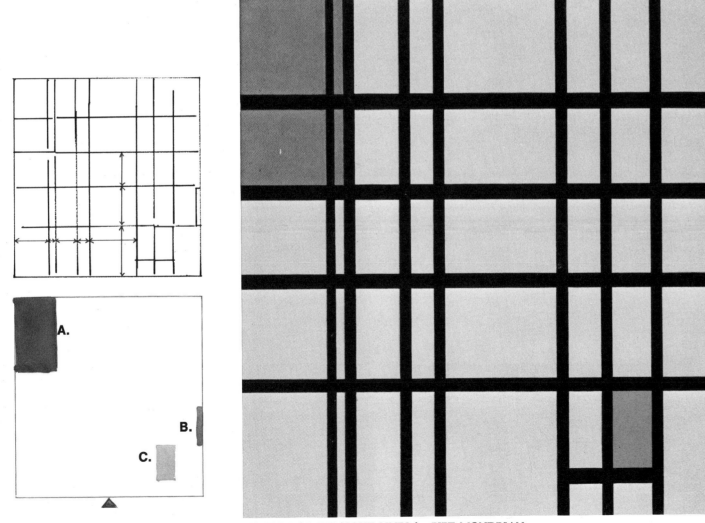

RHYTHM OF STRAIGHT LINES by PIET MONDRIAN
Henry Clifford, Philadelphia

WHAT TO PAINT AND HOW TO BEGIN

Since nature is our source of information, our inspiration and our teacher, it's time we went outdoors.

Living in New England, my outdoor painting time is much shorter than I would like. However, I do manage it from the middle of March to the end of November. Painting is enough of a problem without also being made miserable from the weather. The time of day I prefer to paint is eight to ten thirty in the morning. This is ideal, because the sun causes distinctive cast shadows and shadow formations that can become quite important in your composition. Early in the morning the color is fresher, and you yourself are more alert. The real start of my painting is usually the night before. This is the time to check logistics. First, I staple my paper to the drawing board, and check over my supplies to see that I have everything ready for the trip. The next morning I double check and load the station wagon. Along with your paint, easel, drawing board, brushes, water and whatever other equipment you will need, you should also think of your personal comfort while on location. During the cold, damp weather dress or overdress accordingly. In bright sunny weather a hat with a visor is necessary. Glare is a nasty enemy. Insect spray is also helpful. There is nothing in the universe more bothersome than having flies or mosquitoes plaguing you while you're trying to concentrate on a brush stroke.

When you arrive at a location that catches your fancy it is wise to check with the owner (if he's around) for permission to venture out on his property. More times than not, people will be understanding and hospitable and even rather intrigued to have an artist feel his place is worth painting.

Before toting all your gear from the car, I have found it wise to carry only a viewer, a sketch pad and a pencil on your initial scouting tour.

When you've settled on the view you want, after making several thumbnail sketches for composition and angle, you can then go back for the rest of your stuff. Too often, you can traipse around like Dr. Livingston only to decide that the location does not live up to its promise.

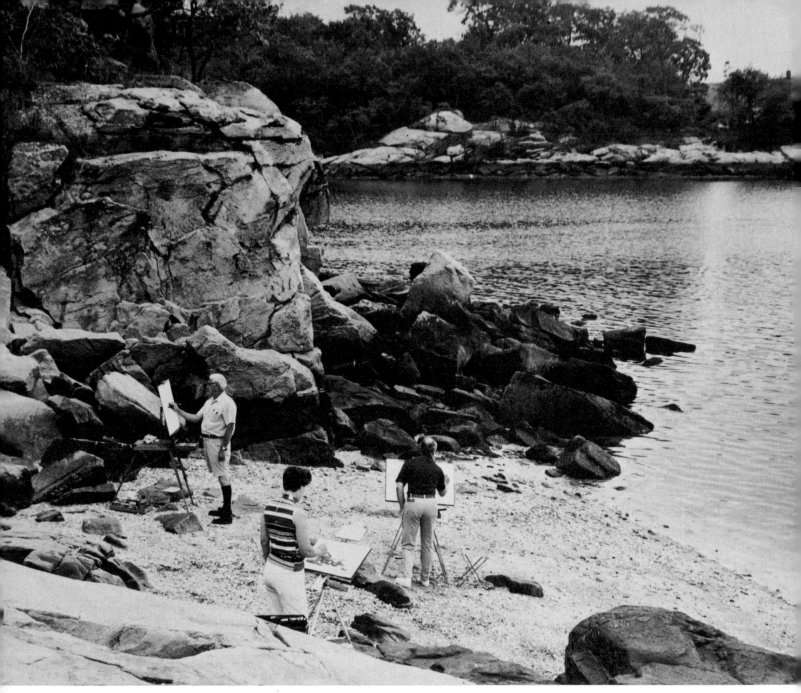

*A long view of the subject includes too much random information
for a successful literal painting.*

I recently took a group of my students out on location near Branford, Connecticut, where a wall of rock came down to the water's edge of Long Island Sound. This was an ideal kind of setting for a landscape class, since it provided so many vantage points and gave an opportunity for a selection from so many aspects of the same setting. It also gave me the chance to teach them to avoid painting a panorama.

It's a common fault with beginners to try to include everything in sight in their pictures just because it happens to be there. After a lifetime of painting nature outdoors, I still must constantly remind myself to keep it simple and to be *an artist, not a camera!*

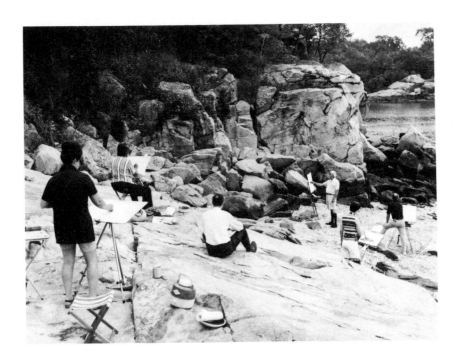

Here each student has selected a different aspect of the vista which can be composed into a successful picture subject.

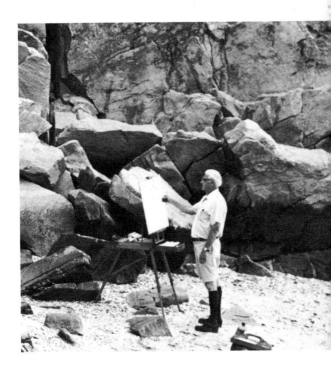

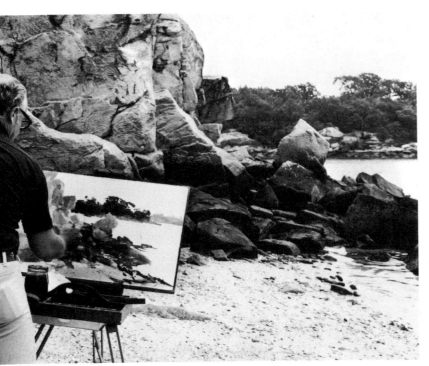

I've chosen an eye level closeup of the foreground rocks, with a view of the peninsula beyond.

If the day is brilliant, try to arrange your position so the paper will be in the shade. If you let the sun hit it, it will cause a glare and a false brightness that will not only hurt your eyes, but will cause you to paint much darker than you mean to. Such pictures are totally out of kilter when viewed later in normal light.

Also, the sun heats up the paper and dries out your color much too rapidly. This makes it difficult to control washes and edges.

Now that you're comfortable, the next step is to block in your composition. This will probably be an adjustment between your original thumbnail sketch and your second look in relationship to the bigger paper area you are now dealing with.

Here are three general ways to paint in a sitting or standing position. I prefer to stand because I can easily step back from the painting to study its progress. There is also a certain feeling of freedom when you paint standing. I also prefer the more vertical position of the drawing board even though wet washes tend to run down the paper. This is easily caught with a sponge when necessary.

When all is settled and you're completely set up, study your subject in an abstract way. Don't get involved with the entire countryside. Narrow down your choices to simple shapes. There is a certain strength that comes with simplicity — it's as true with pictures as it is with people.

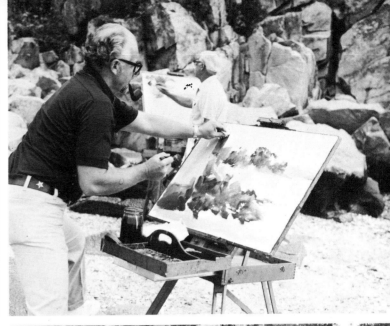
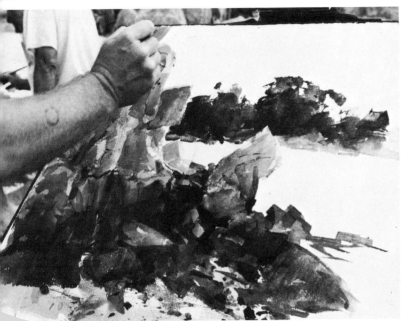
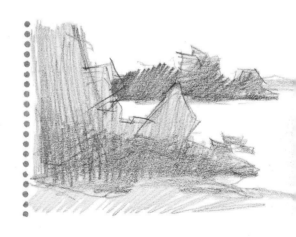

When drawing previous to painting, remember not to outline everything so completely that you find you're coloring a picture instead of painting a watercolor. The pencil should act merely as a guide, and your brush should take on most of the responsibility. When you're ready to paint, concentrate on the three value approach. Look at the landscape and ask yourself what mass area is the darkest, which area is the middle tone and which are the light ones.

These first attempts with watercolor should be bold and spontaneous. Cover the paper as quickly as possible. There is no formula for handling watercolor, but you might consider this general basic approach. Paint from top to bottom, back to front, large to small, which means large areas first. Also, large brushes first then finish with small brushes (lights to dark).

Now step back and study your work as you proceed. Above all, don't be afraid. I usually start with the sky because it helps the mood. However, if the sky is part of the major light, I might not touch the paper at all and leave it as just white paper. Don't get "hung up" trying to follow the basic procedure that we have mentioned, but let the subject dictate to you the way that would seem easiest and most natural. Your own personal procedure will come, and it will also vary according to your subject.

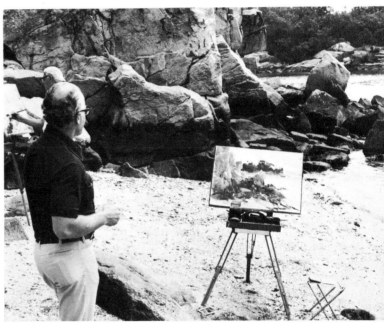

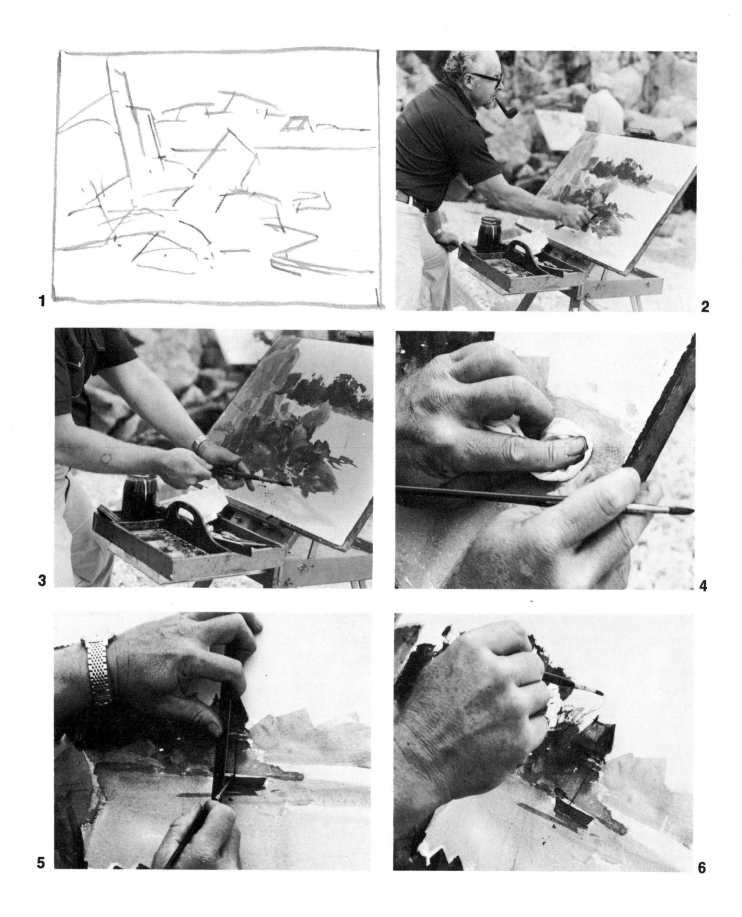

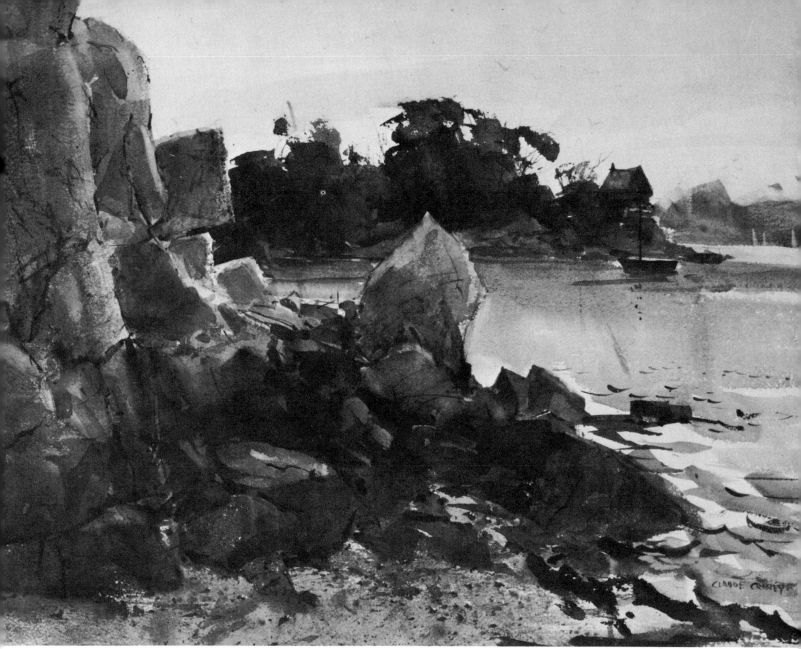

CASTLE ROCK NO. 2

We have already talked about some of the technical means of achieving particular effects. Here are some employed in the finished picture above.

1. The first step is the pencil sketch. Although not a detailed drawing, the composition is solved here, so that none of the elements will have to be changed later.

2. Let the subject determine the technique used. Here, a palette knife used like a scraper, is just the right tool to suggest the plane of a large rock.

3. It would be foolish to even attempt to paint in the texture of the beach with the point of the brush. A spatter gives just the right random look of the mixture of sand and gravel.

4. Paper tissues are a must for correcting areas to be lightened or removed by blotting.

5. Occasionally, a detail, such as a flagpole, mast of a boat or edge of a building, may require a straight line and a ruler provides a steady support for hand and brush. Use a ruler *very* sparingly, however.

6. Only at the very last end should detail be considered or a small brush be used. This stage is like putting the icing on the cake.

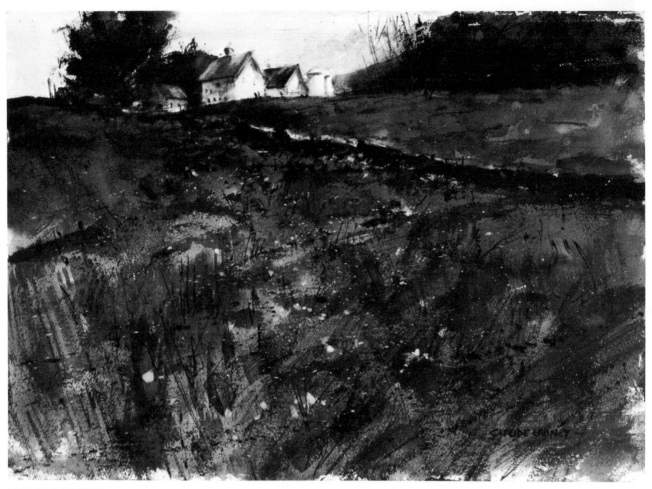

SOUTH PASTURE

CHAPTER 6

APPLICATIONS OF TECHNIQUES

MANY students are frightened by the prospect of painting certain subjects in nature — things like trees, water, foliage, skies, rain and snow, waves, wood, rocks and fields of grass.

Don't be intimidated! To be sure, the rendition of some of these is more difficult than others — but these subjects can all be mastered by knowledge and practice. Actually, they can all be achieved by the simple techniques discussed in Chapter 2. It's important to use methods that suggest the *character* of your subject.

Equally important is the necessity of keeping your textures relative to the picture space. In other words, the most *distinct* textures should be planned for the foreground and become less obvious as they recede.

A variety of texture adds visual interest to a picture. For example, a painting of nothing but hard edges or nothing but soft edges would result in a less exciting picture than one that played these two possibilities against each other.

As I continually stress: don't feel you must slavishly follow my methods. Start with them, then find your own individual way.

One of the qualities that makes watercolor such a distinct and beautiful medium is its freshness — mostly one thinks of it as one bold sweep or swash and out; and, in the main, that's true. But there are times when it's perfectly legitimate to go back and rework certain areas. This is especially true in textural areas; not only do I sometimes rework areas — I often *overwork* them to gain certain textural results.

Let's look at some examples: **1.** This painting was done on the spot. As you see, the foreground field of grass takes up most of the picture area, so upon its success rests the success of the painting. This is a good example of what I meant by keeping the texture relative to the picture space. Notice how I've controlled the field's recession by treating texture boldly in the foreground and minimizing texture as it goes back towards the buildings.

Grass at first glance often seems monotonous — only a sea of green. But when you study it with a painter's eye, you find it has infinite variety. Look for the direction in which it grows — look for the other things that grow *in* it. You'll come to discover an endless diversity of texture and color and surprises.

I've broken the picture down to these three simple beginnings to show you how to proceed: First, diagram **A,** I've covered the entire grass area with a local color, then some variations were painted in while it was still damp. In diagram **B,** I started to add some drybrush along with some thin lines with a pointed brush. Notice how I'm keeping the foreground relatively stronger than the area in the background.

In diagram **C** there were some light yellow flowers to complete the effect, but rather than paint around them I thought it would be easier to add them in an opaque manner. So I mixed a little bit of acrylic white with a little yellow watercolor and made up a mixture to be added as an opaque light spatter tone. Then I added some dark spatter. Now lastly, with the tip of the brush I applied a few larger spots near the foreground.

A. **B.** **C.**

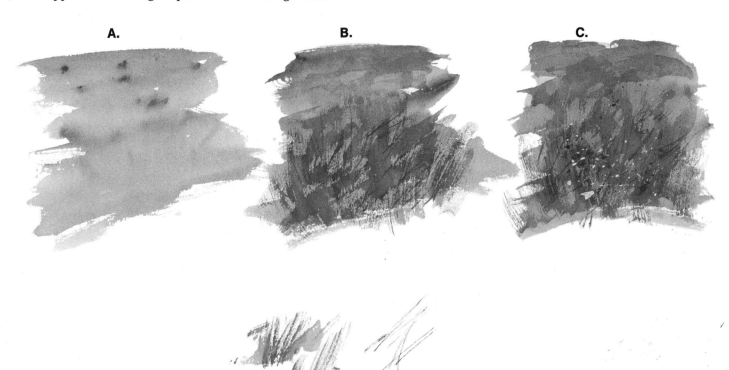

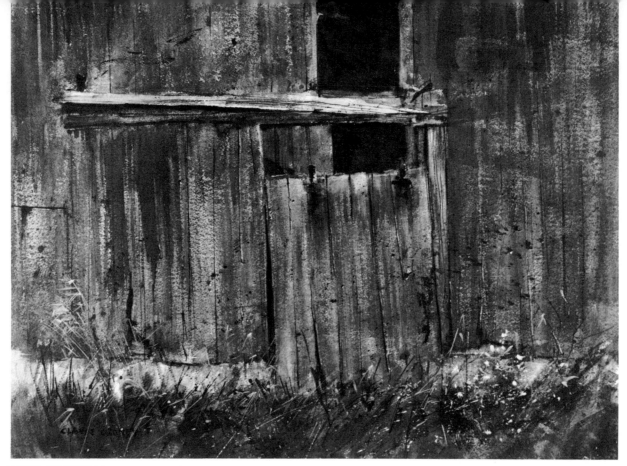

BARN PATTERNS

2. Next, a close-up of a weathered barn. Ordinarily when I do a barn I don't go into detail as much as I did here. But since this is a close up and the character of the old boards intrigued me, I decided to go all out to capture everything I saw.

This is how I proceeded: In diagram **A** I covered my paper with a local value and color. In **B** I added some dark drybrush over this lighter local color. Notice how this local tone shows through within the texture of the drybrush that has been applied over it.

In **C** I added some thin lines with a pointed brush. These were used to suggest the cracks between the boards. Along with this I applied some dark spatter tone to add texture and variety.

In **D,** after the painting had dried, I used a razor blade to scrape out a light edge on one side of the boards next to the dark lines. This is done to emphasize the light catching the edge. I did the same to some of the spots and spatter that were applied previously.

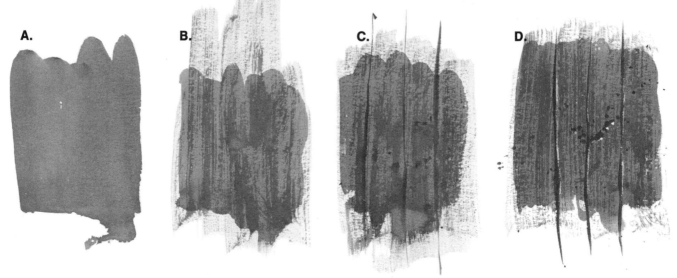

A. B. C. D.

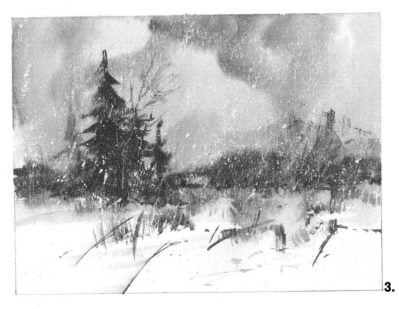

3.

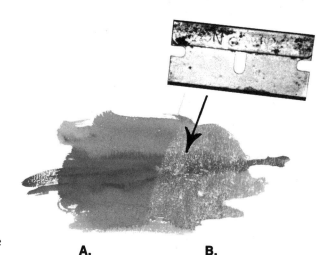

A. B.

3. This painting is a small snow scene. Most students have trouble suggesting snow. Take heart! Here is the method I use.

In diagrams **A** and **B** simply paint your tones just as you ordinarily would if you were depicting a clear day. After this is dried, razor-scrape the surface of the paper. This effect is best achieved when working on a rough textured paper. The razor shaves off the paint on the raised surfaces. You can carry this to any degree you wish. Just be careful not to scrape the whole painting off the paper. After starting to set the mood with this razor scraping I then added some white spatter tone. This helps to add variety and bring some of the snow flakes closer to the viewer and in so doing, helps to strengthen the illusion of space and depth in the painting.

4. A rainy day. I'd like to point out some of the characteristics of a rainy day. First of all the sky is quite light, but since the sun is obscured the whole sky becomes the light source. Edges appear much softer, so the use of wet-on-wet particularly in the background would be helpful. Wet areas that face the sky will reflect much of the light from the sky.

After I have completed my painting, keeping in mind the need to get the proper values in the proper place, I completed the effect with a very sharp razor, scraping out some thin lights. It's important to keep the scrape marks all in the same general direction.

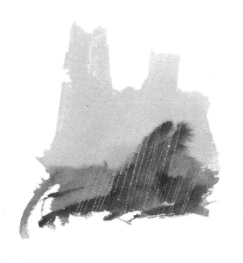

4.

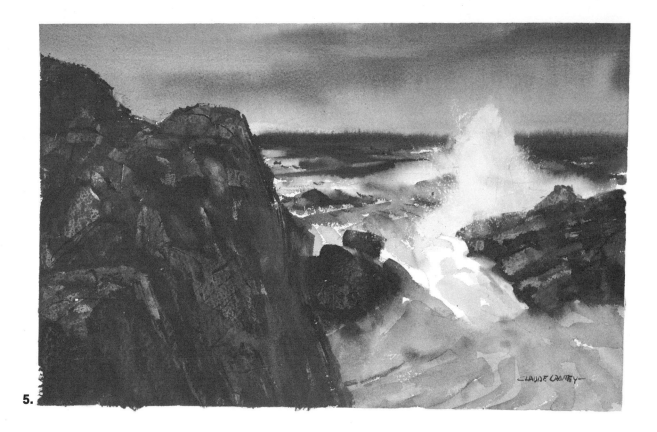

5.

A.

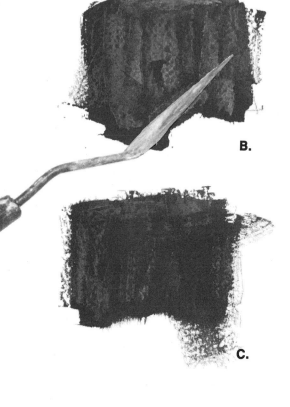

B.

5. Seascape. Now to rocks. They come in an endless variety; sharp, light, dark, stacked, cracked, tumbled and so on. In this case I'm dealing with the rugged rocks of the Maine coast. First I covered the entire rock area on the left with heavy thick watercolor paint — diagram **A.** In **B** I used the side of the painting knife to squeegee and scrape the paint, moving it and pushing it around on the paper. Here again, the texture of the paper helps.

In **C** I added some drybrush over the area I scraped and kept in mind where I wanted the shadows relative to the light areas. This was done to retain the rocks' forms.

After the darks were added **D** I worked back into them with the painting knife. At this point I assessed the accidental things that happened. I kept the things that had rock-like characteristics.

In **E** I added thin dark lines to suggest cracks and the cragginess of the rocks.

In **F** we are ready to complete the effect. I used a blade to scrape out some light next to the dark thin line to suggest where the light picked up the edge of the rock next to the crack. This is very similar to the method used on the old boards. Now if there are some areas that are still too dark and you want to throw back some reflected light you can use a wet bristle brush to dampen the area, loosen the color and then remove by blotting with a tissue.

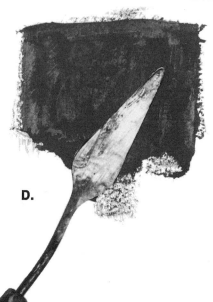

C.

D.

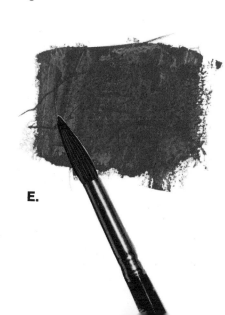

E.

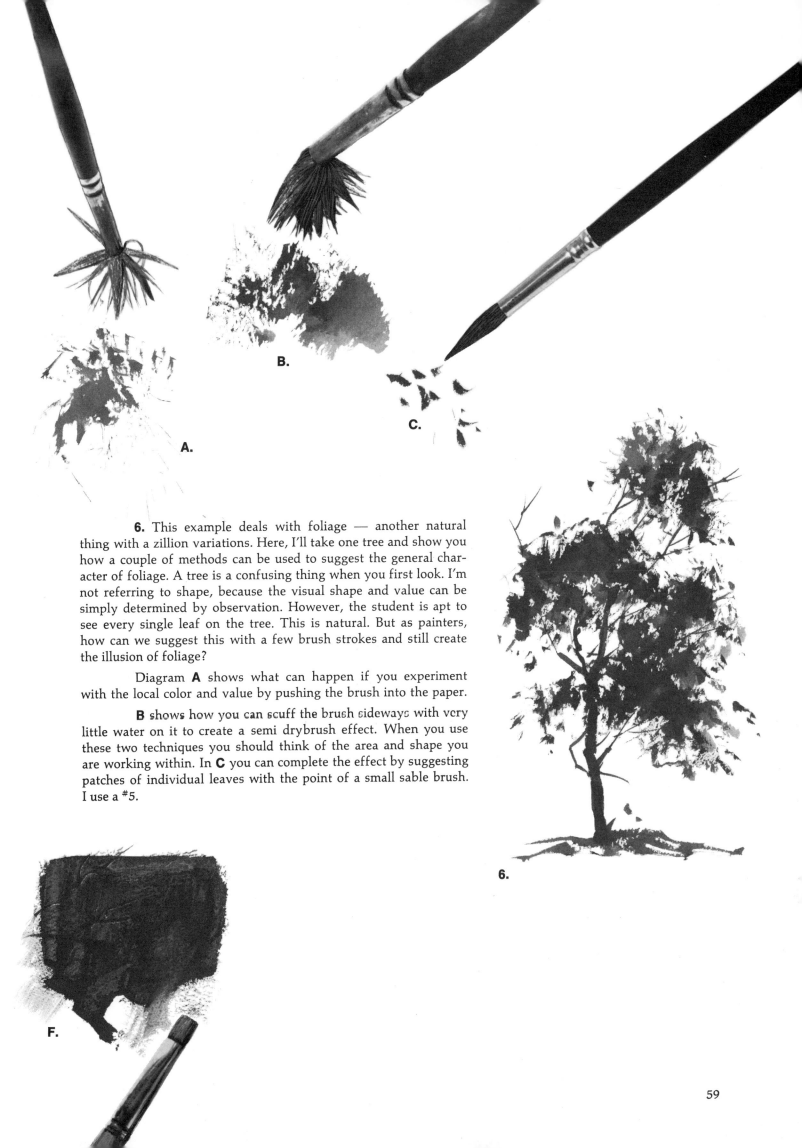

6. This example deals with foliage — another natural thing with a zillion variations. Here, I'll take one tree and show you how a couple of methods can be used to suggest the general character of foliage. A tree is a confusing thing when you first look. I'm not referring to shape, because the visual shape and value can be simply determined by observation. However, the student is apt to see every single leaf on the tree. This is natural. But as painters, how can we suggest this with a few brush strokes and still create the illusion of foliage?

Diagram **A** shows what can happen if you experiment with the local color and value by pushing the brush into the paper.

B shows how you can scuff the brush sideways with very little water on it to create a semi drybrush effect. When you use these two techniques you should think of the area and shape you are working within. In **C** you can complete the effect by suggesting patches of individual leaves with the point of a small sable brush. I use a #5.

A.

B.

C.

6.

F.

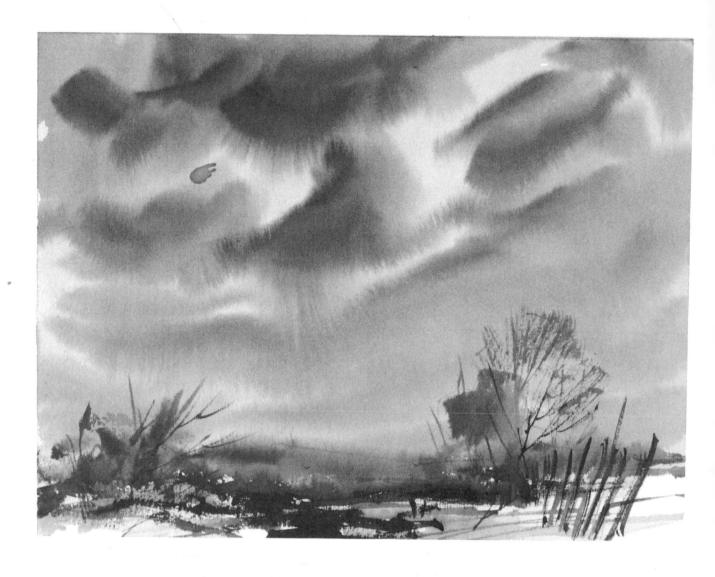

7. In this sketch I am going to talk about methods for painting the wet dramatic sky. I use them often in my own paintings and whenever I do a demonstration. Most students are fascinated by this aspect of watercolor. This is a sky that you must do quickly. Many beginners have problems with water marks because the paper dries too quickly. Here is the method I use. First I dampen the entire sky area with a sponge or brush and clean water, then I add a pale wash of color over the entire sky area. While the paper is still pretty damp the next step is to quickly brush in some darker tones. Don't try to work into it after it is dry. You'll be more successful if you use lots of pigment when you add your variations into the wet surface. (What looks like a dark mixture becomes lighter as it dries on the paper). And, if you go beyond this as I often do, with still darker tones for variations, you'll need still more pigment relative to water for each progressive step.

The more level you keep your drawing board, the more control you'll have, but you lose some of the drama. I like to keep my drawing board at a very severe slant as I add the darker tones into the wet surface, so that the paint tends to run down a bit. With a little practice, you'll get the feel of this and learn how to control it.

8. Now — water. As in all nature, water has differences too. We know there is a flat smooth surface of lake water, and there is the pounding surf on the coast. We shall concentrate on water that is fairly flat with only a little movement. Here again, you can make adjustments to suit your own needs. Water of course, is treated quite differently from the sky or grass. It's a flat surface so you try to stick to more horizontal brush strokes to begin with. I usually use a combination of choppy brush strokes to suggest the movement of water. **A,** I start out with a light tone. Then in **B** before this light tone dried completely I added a darker tone letting some of the brush strokes overlap and touch the other tones. As I completed the effect I added still darker tones. You get a combination of hard and soft edges that helps to create this feeling of wetness, and by letting some of the white paper show through, you'll add sparkle to the water which is of course one of its characteristics. Keep in mind that the ripples and the movement of the water are most obvious in the foreground. **C.** To indicate the same motion in the distance I often suggest it with some simple horizontal drybrush strokes. Practice these techniques and use them in your paintings. The prime purpose of this chapter is to show you how *one* artist works. All artists learn from each other. Before you know it, you'll be passing on *your* version to newcomers less skilled than you.

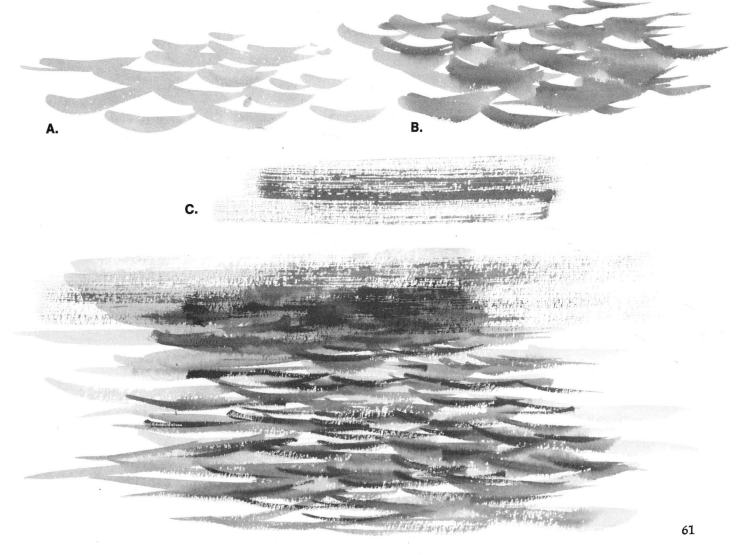

A.

B.

C.

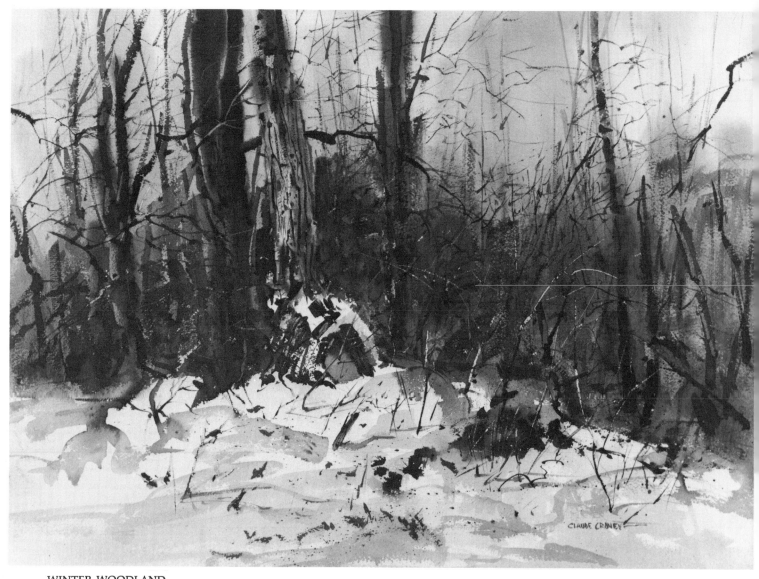

WINTER WOODLAND

PROBLEMS AND SOLUTIONS

IN THIS chapter I've selected several random technical and pictorial problems that you are certain to encounter as a watercolorist. In each case I've supplied a solution that I've worked out for myself — you can take it from there and turn my findings into your own way of solving things.

1. A common fault mostly to be avoided. **A.** This shows what happens when you use the wet-on-wet method with the second wash lighter than the first — and to make matters worse, the first wash has started to dry. This creates a dark hard edge or a water mark. It's one of the most common problems that a student encounters. However, there are times that you will want this effect, so learn its good and evil effects.

B. The lighter tone was painted into the darker tone, wet-on-wet again but this was done while the under tone was still completely wet. This is a difficult effect to control. Practice it.

C. The easiest way to control the wet-on-wet method is to paint your darker tones into your lighter tones. In other words, as you are making your variations, use more pigment for your darker tones relative to the amount of water. Remember that the under tone is already wet and contains a certain amount of water to begin with.

A.

B.

C.

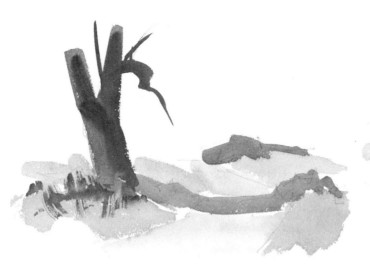

2A.

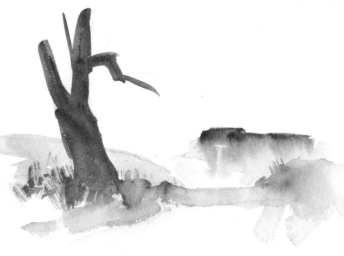

2B.

2. This shows a cast shadow across a road. **A.** Beginning students are apt to separate the cast shadow from the light local color of the road. In other words, they paint the shadow in and after it dries they paint in the light part of the road around it. This leaves a disagreeable white edge around the outside of the shadow's shape.

B. Try it this way. Paint the light tones in first for your local color of the road, and then after it is dried, paint the cast shadow, using a transparent wash over the road. This transparent wash will let some of the local color of the road show through, creating a more natural color effect.

3. Another problem. **A.** Here, the tree was painted in first, then the sky was painted in around it. Again, this left white areas on the outside area of the trees. This also makes the sky a little more difficult to handle especially if you are using the wet-on-wet technique.

B. You'll find it easier to paint the sky in first, covering the entire sky area, painting right over where the tree is to be. After it's dry, put the tree in. This also gives you freedom in putting the sky in just the manner you wish without being concerned with going around the shape of the tree.

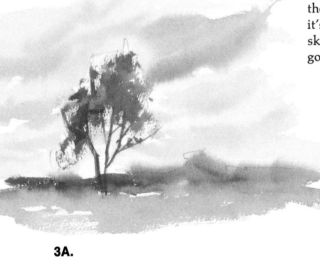

3A.

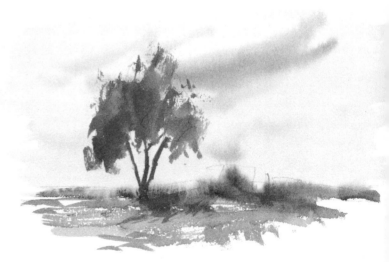

3B.

4. Here we have two white buildings with black roofs, windows and a door. **A.** It's easy to take a quick look and paint all of these areas plain black. But that would be wrong. Read on.

B. This is what actually happens when you study the scene. First of all, one building is set back further in the distance relative to the other building. The open door way of the building in the foreground will be of the darkest value, since this area is inside. The roof faces the sky more directly and will pick up some of the light. The roof of the building in the foreground will be darker than the roof of the building in the distance because of its proximity to the viewer. Darks appear lighter as they recede. The white paper was used for the white of the building in the foreground, but you'll notice I've lowered the value just a bit on the building in the background. This is another important thing that happens to values as they recede. White becomes slightly grayer as it moves back into the picture space. This control of values helps you to create the illusion of reality and a feeling of dimension and space in your work.

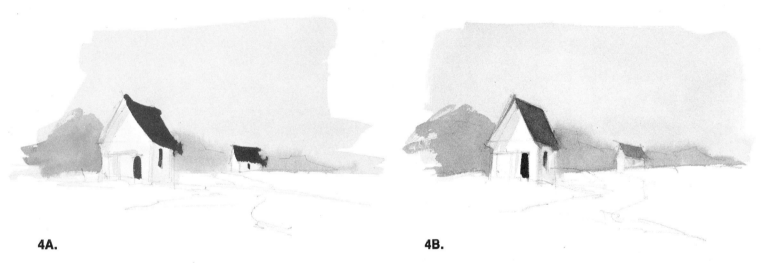

4A. **4B.**

5. It is usually best to paint from light to dark. **A.** Here, I have covered a dark swatch with a wash of yellow to illustrate the folly of trying to revive a painting that has gotten too dark. Don't do it. This gives the color and the work a very tired, chalky and over-worked feeling. Much of the crispness of the watercolor is lost after yellow is used over a dark color; this applies to all light colors such as Cadmium yellow, yellow ochre, Cadmium orange, Cerulean blue.

B. You can see the more crisp effect of using a dark over the light. There are more times when you want to put a pale wash of a light color over an area to modify it or adjust it. That's okay. For example, after a sunlit scene dries completely you can lay a pale wash of yellow ochre over the entire painting. This is to give an overall feeling of sunlight. However, you have to be very careful when you do this so as not to disturb the under colors.

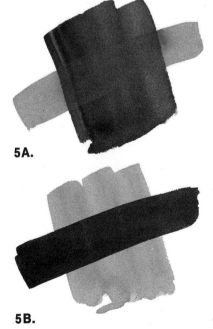

5A.

5B.

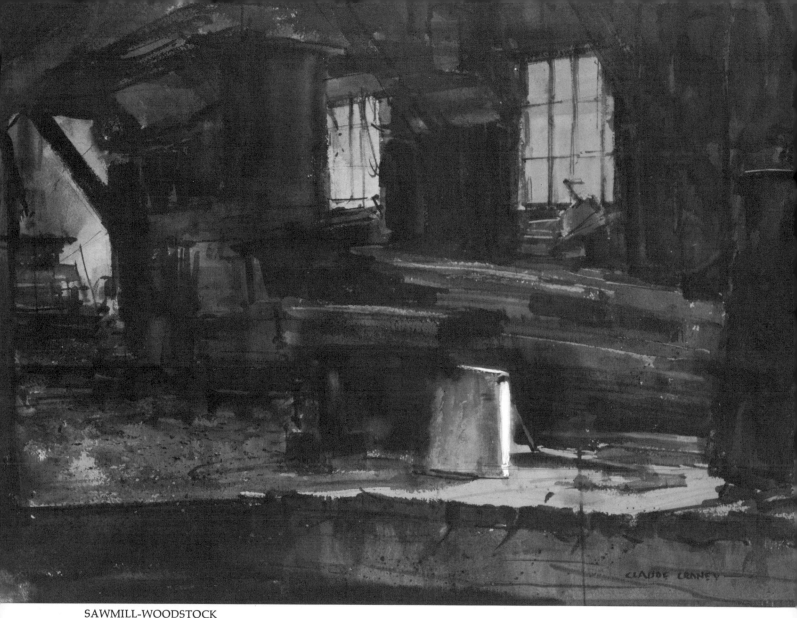

SAWMILL-WOODSTOCK
Winner of Emily Goldsmith Award, American Watercolor Society.

6. As I've presented the three value approach to picture making so far, I do not want to leave the impression that these should be only three specific values, like three notes out of a scale on a piano. That would make for pretty dull music — or pictures. Rather, think of the three values as three groups of darks, lights and middle tones.

The above picture illustrates this point. (In the diagrams I've simplified the picture to the dark and light patterns only.) It is

Equal lights in each of these isolated areas call for equal, competing attention.

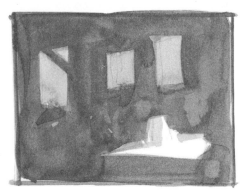

By lowering the lights in the windows and doorway the strongest light is concentrated on the pail as the focal point.

immediately apparent that in the first diagram the three equal areas of light make for a spotty composition. By applying a subtle wash of tone over the lights in the windows and doorway, as indicated in the second diagram, I've been able to emphasize the pail in the foreground as the center of interest. At the same time the windows and doorway still remain as part of the over-all light pattern.

A.

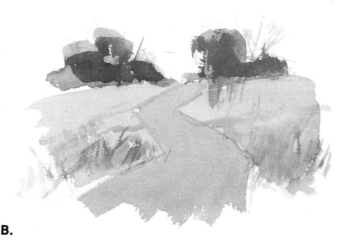

B.

7. These examples suggest a flat plane moving back into the picture space. Diagram **A** might be water out in the open sea. **B** is meant to suggest a road moving back over the countryside. The student usually paints the road and water as flat values and similar, from back to front, or top to bottom.

C.

D.

C. You can give the planes a feeling of distance by using some gradual value change, either from light to dark, or dark to light. Notice how the value of the water is lighter in the foreground, and how this creates a feeling of dimension and distance. **D.** Study this road, and observe how I've made it a bit lighter as it moves back into the picture space.

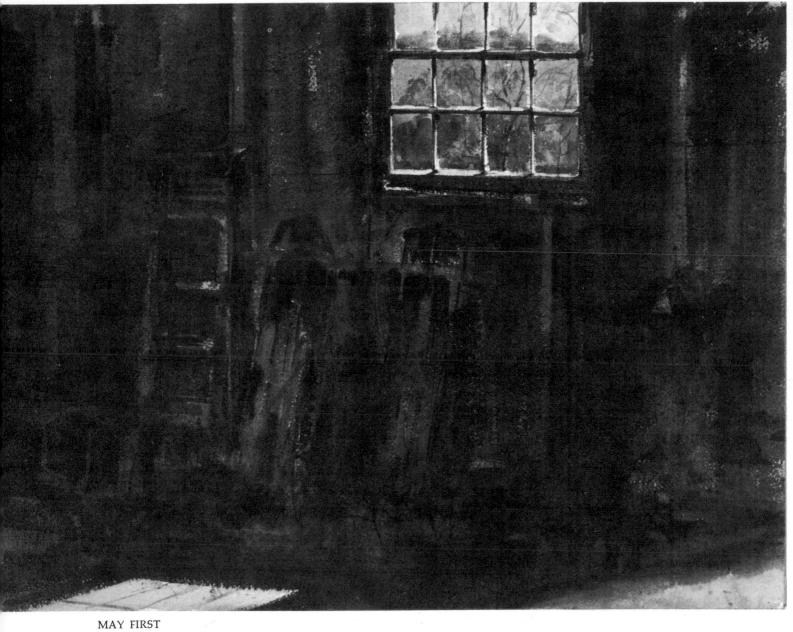

MAY FIRST

A.

B.

THINKING AND PROCEDURES

I'D NOW like to show you several of my paintings and then take them apart to share with you the thinking and procedures that produced them. This seems to me the simplest and most effective method of demonstrating my beliefs and working habits. Bear in mind the thing I've preached all through this book: practice these methods — gain a facility — learn to look — then fly out of the nest and take off on your own!

1. "May 1st" 21" x 29". This was painted on 300 lb. rough D'Arches. It was done on the spot in my garage. What caught my eye was the light through the window which created a strong pattern against the dark interior. Also, I was intrigued by the complicated and diffused shapes in the dimness. And of interest, were the pale tints of green outdoors that suggest spring; this, with the winter sleds indoors, created what I thought a poetic and paradoxical subject to paint. It also makes a good subject to use as a demonstration because most students tend to make everything sharp and detailed. Here the interior objects being in shadow, had to be softened and diffused to suggest the sparsity of light.

A. I blocked in the window with pencil and barely indicated some of the other shapes. Next I wet the entire area with a sponge (this helps to avoid white spots). I then painted a tone over this entire area with a two inch flat brush. I was aiming for a middle tone, but as it dried it became much lighter. That was okay because I knew I was going to add more wash and texture. They would darken it further.

B. While this tone was still wet, using a #12 round sable I painted in some large dark variations indicating some of the shapes. Notice how the dampness of the undertone created a soft effect. I wanted this diffusion to suggest interior darkness and shadow.

C. To avoid confusion I didn't combine this step with the previous ones. This is a demonstration of dry brush calligraphy and my small "nervous" brush treatment. This is the stage where I add point or edge to the painting. It is also called *accenting* a painting. Notice its effect. I worked over the entire painting, adding drybrush, a flat simple dry stroke here, a thin line there. You can control the amount of edge and crispness you want. Remember that the underneath tones were done while the paper was still damp and that left some soft edges. Strive for a finished picture with a balance of edge effects that satisfy your eye — neither too blurry nor too hard-boiled. The thin lines were painted with a #5 round sable brush.

C.

2. "Saugatuck" 21" x 29" — 300 lb. rough D'Arches paper. This painting was done on location. I was struck by the heavy dark structure with the light boat against the dark shadows of the water. The small boat on the left was out of the picture space, but I felt it needed something in that area to help balance the heavy mass on the right. Also, its dark shape against the light background added to a better feeling of balance of the whole design.

A. First, I made a thumbnail sketch for composition. Then I re-drew it on the watercolor paper and laid a pale wash over the entire top area, going over the sky and trees with a 2 inch flat brush. Before the sky dried, I painted in a strong tone for the trees.

B. Notice I didn't try to stay too long with the trees, but proceeded to come down with a healthy dark tone over the bridge area, and below that, the underside of the bridge.

C. I continued down the paper leaving a place for the white boat and covering the water area with some dark horizontals added into wet to suggest the movement of water. Then I went back and painted the darker boat on the left. By the time I got to this stage I could stand back from my work and see how the values related and how the impression of my subject was progressing. Notice the absence of detail so far. My aim was to quickly cover the paper with the approximate value and color.

D. Here again I've isolated the detail for purposes of demonstration. I used a two inch varnish brush to add some of the heavy drybrush texture with vertical movement alongside the bridge. Then I went around in sort of dot-dash manner to pick up edges where I felt it necessary. I also tried to think of the character of the surface of the painting. For example, I've added some drybrush and some horizontal brush strokes to suggest movement in the water. Short choppy brush strokes were added to suggest ripples.

A.

B.

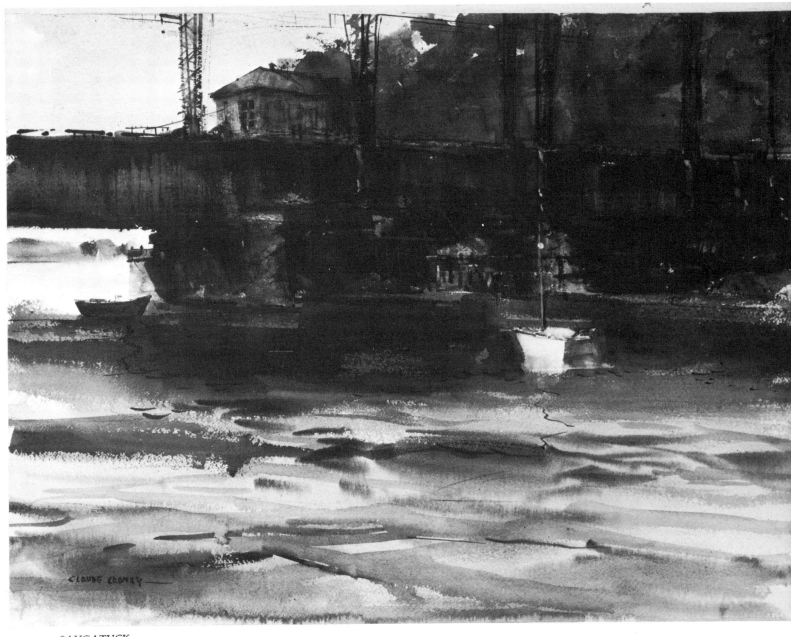

SAUGATUCK

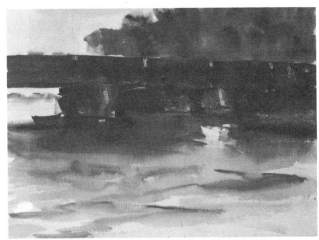

C.

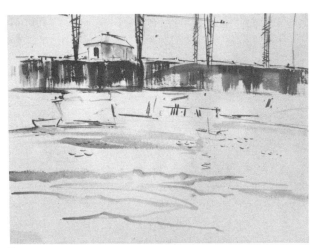

D.

AWAY FOR THE SUMMER

3. "Away for the Summer" Full sheet D'Arches 300 lb. paper.

Sometimes the most difficult problem is in recognizing a paintable subject.

Ordinarily I wouldn't have seen a picture in this old house, but I was attracted to the subject's strong, abstract shapes. A second look made me aware that there was a picture idea in the closed up old house and overgrown yard.

Notice how I just established the value pattern of lights, darks and middle tones with a preliminary pencil sketch. In these small sketches one should concentrate on pattern and design and not fuss with details.

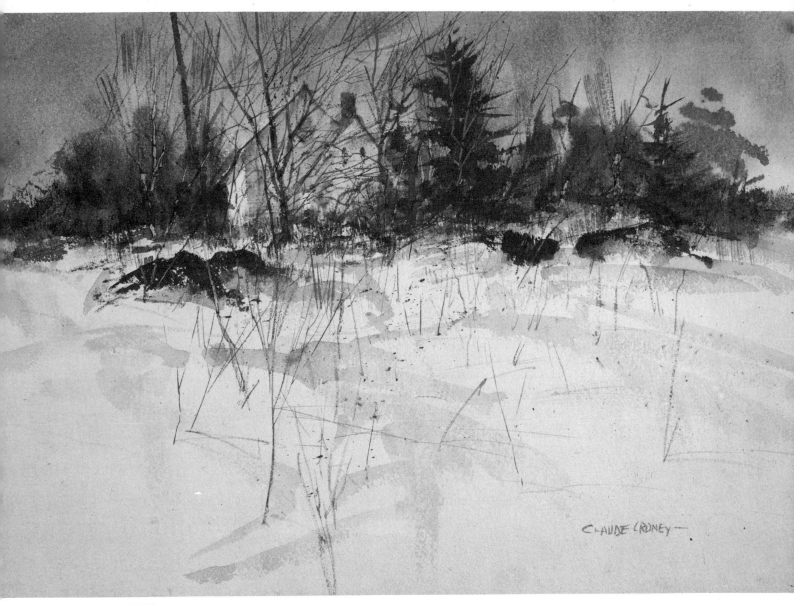

WINTER LACE

4. "Winter Lace" 14¼" x 21¼" D'Arches paper.

In this case I came across the subject while driving. The only materials I had with me were an old envelope in the glove compartment and a pen from my wife's pocketbook. I made the quick sketch. And, from this meager but vital information coupled with memory I went back to the studio and painted it.

The success of the entire picture depended upon the textural pattern of the lacy branches superimposed on the old house, the trees and snow.

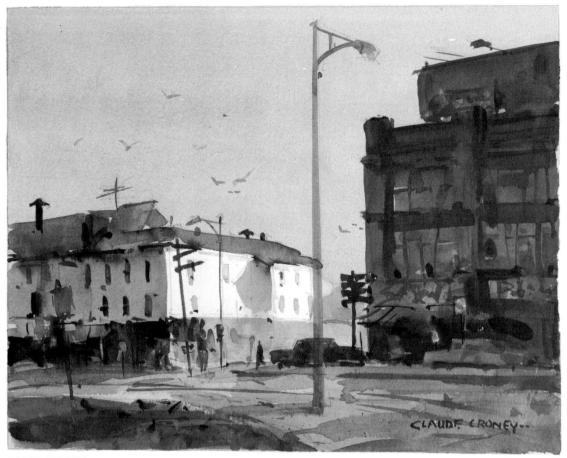

MAIN STREET

5. "Mainstreet" 8" x 10" 140 lb. Fabriano.

This painting was done in my studio. I rarely ever paint city scenes, probably because I like the country and the moody landscapes, with old barns and weather-beaten boards, but I know there are many painters who live and work in the city by preference. There is plenty of material there to paint. One's concepts and artistic approach are not any different there than they are for landscapes and seascapes.

A.

B.

A. I sketched this one indoors to avoid the traffic and street confusion. My approach was the same as it would have been for a bucolic landscape. What caught my eye here was the dramatic light hitting the side of a white building, with the large dark brown stone building on the right in shadow. Next, I considered the variety of shapes. I noticed the vertical shaped building on the right and used it against the more horizontal building on the left. This kind of variety helps to create an interesting composition. I made value and color notes on my black and white sketch.

B. Back at the studio I did a simple small value pattern before I tried approaching the finished painting. Notice how I used a very simple light, dark and middle tone pattern with absolutely no detail. I knew I'd use the white paper for the light-struck side of the white building. The sky is part of this light pattern also, but in order to dramatize the light on the building I used a slightly lower value for the sky. In that way, I took full advantage of the white paper. I proceeded to paint it in the same manner I would do in a landscape. I covered the paper as quickly as possible, then went back to the small brush for accents and detail. The color in this painting is fairly factual. The only change was to make a blue sign red, near the corner of the white building. I felt that the red would act as a warmer, brighter note near the focal area.

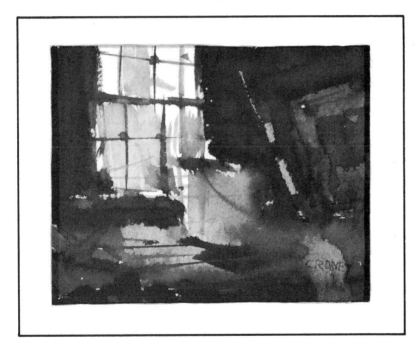

6. Let's discuss very small paintings. This was painted on Fabriano — 140 lb. The size is 3½″ x 2¼″. It was actually a small value and color sketch for a larger full sheet watercolor. You can do a small sketch like this very rapidly.

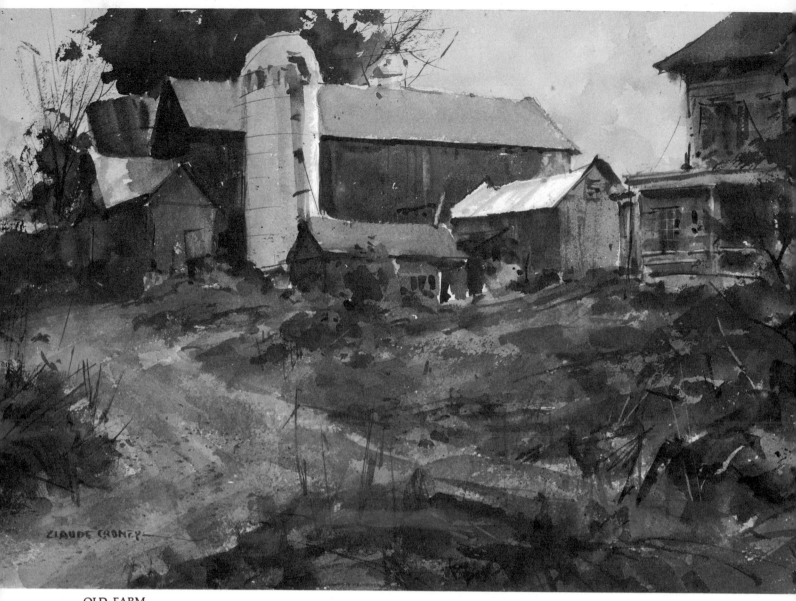

OLD FARM

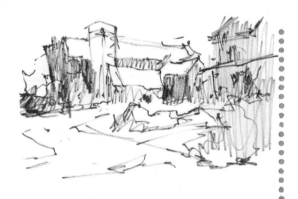

7. "Old Farm" 14" x 20" D'Arches 300 lb. rough. I prowled around the area and made a number of sketches before settling on this view. I was intrigued by the interesting shapes of the buildings — first abstractly — then literally.

A. Based on my sketch I blocked in some of the dark shapes. Then I laid a pale wash over the entire sky area and the building that is in shadow on the right. Before this was completely dry, I painted in the building that is in shadow. Notice how some of the edges blurred. (I'll come back to that later.) The dark shape of the barn was painted in next. I hasten to cover the paper as quickly as possible.

B. Next, I put in the tree in the background and the other values for the building along with the ground grass and road. This part of the painting moves very quickly. Remember the *value* is all-important! While the paint was still damp I scraped out some lights in the foreground to suggest light-struck grass and highlights. I added darker washes in some areas to build up texture and tone in the grass. I didn't worry about rough effects because the tone underneath will show through. Always bear in mind the character of the

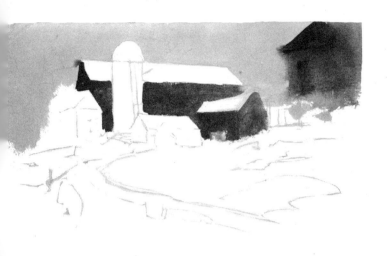

A.

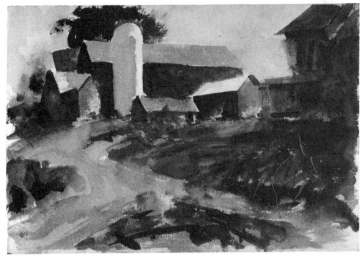

B.

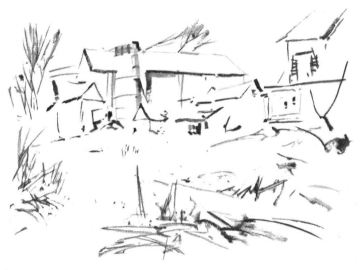

C.

surface that you're painting. At this stage you should take a squint at it and if you've hit the value correctly, you'll have the feeling that the painting is completed. Of course at closer observation there is more work to be done, but the extra detail work will not change the overall pattern.

C. Here I used a #5 brush mostly to suggest thin lines for branches and grass, with a little drybrush to suggest a mass of branches and added texture. Look at some of the areas on the silo and notice that the dark accents have been blurred. One can do this in two ways. You can either wet the area down, add the dark accents into it while the paper is damp, or you can simply add the dark accents into it and where you wish the tones or accents to blend, run a little clean water over or next to them before they dry. This is a step I mentioned before, where I work over the entire area, not trying to finish any one spot or shape, but to quickly move from one area to another, building up and completing the painting. Try to keep the whole painting going at once. Someone once asked me, "When do you know you are finished?" When you reach the point where you think another brush stroke will not help, you're finished.

8. "A Walk in the Woods" I would like to touch on the use of the human figure in your painting. This is 6 x 8 inches and was done on 140 lb. Fabriano. It's a small painting so I avoided the heavy textured paper. Also, there is less of a problem in buckling and you can keep the painting under control more easily. If you cover the figure with your finger you'll find that the landscape alone would be quite dull. This is often the reason to add a figure. Or, to add visual interest, animals can be introduced too. If you had a landscape that was already satisfactory and you still wanted a figure, it would be wise to subdue some of the areas to make the figure the focal point. Notice the placement of the figure on the paper within the picture space. I avoided placing it in dead center. Instead, it's to one side to give a variety of space between the figure and the outside borders. This helps to create a more interesting visual effect.

A. Here are my beginning steps for placing a figure in a landscape. If there is a light against dark, paint the dark *around* the light to isolate the shape. I painted the grass tone across the leg area and after it dried, I painted the dark trousers over it. This is as far as most students go when painting a landscape. The hard edges all around this figure as it stands now creates an illusion of its being cut out and pasted down on top of the painting.

A WALK IN THE WOODS

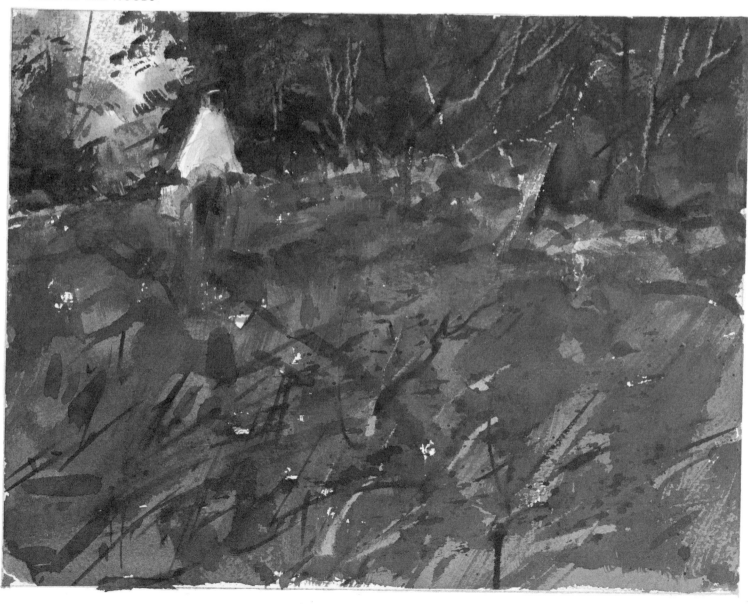

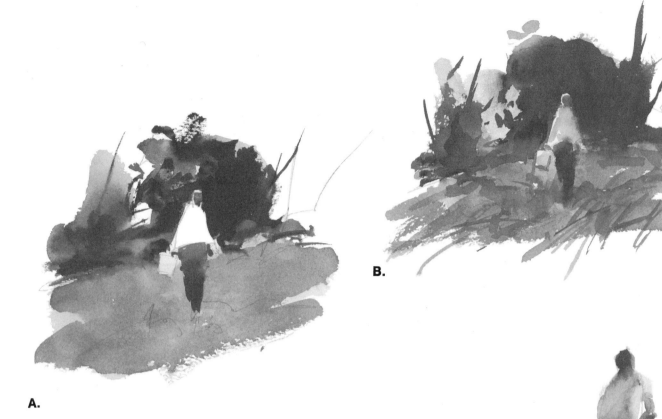

A.

B.

B. See how I gave the figure a feeling of being part of the landscape and made it move within the picture space. You can do this in two ways — lay a very light tone next to the dark area while it's still damp so that the edge blurs and becomes soft. A small bit of wet paper can be left for the highlights along the left side. Or, you can brush the light tone into the dark paint so that it loosens up the pigments creating a soft edge. In the grass area, add a slightly darker tone for variation. But, at the same time brush it over and into the trousers so that the pigment is loosened and the edge becomes slightly softer.

The use of the combination of both hard and soft edges help to create the illusion of the reality.

C. & D. These are practice exercises. Try using burnt umber; you can get dark, middle and light tones with it. Paint the figure in a manner to show movement or action. The figures themselves should be interesting, not just static standing sticks. Think only of the torso, the head, legs and arms. Don't worry too much about the feet, hands or features. Paint them very quickly and don't wait for one area to dry completely before you put another tone next to it. Notice in the first sketch how the edges blur between the head and the shirt as well as the shirt and the pants. You can see how the dark sweater of this woman leaning on the fence blends with her lighter skirt. After the figure dries and you've created a combination of soft edges, go back with a small pointed sable and add a small accent here and there where necessary.

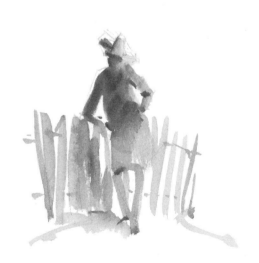

C.

D.

9. "Cliff House" 21" x 29" 300 lb. D'Arches This painting was born from imagination, and I have the sketch here that it was painted from. I always carry a sketch pad to doodle and develop ideas. These are done as abstractions. In this case I became intrigued with breaking up the picture space with a horizontal and vertical movement. Rather than place the horizontal dark in the middle and the vertical dark in the middle which would have been valid, but boring, I chose to arrange this dark shape in a manner that would leave interesting and varied light shapes in back of it.

A. The beginning. I first drew in the major shapes without detail. Then, led by my sketch I painted in the dark horizontal shapes near the top. Then as I came down with the verticals I lightened the tone next to it. I decided here that the sky would be the lightest part of the picture.

B. Here you can see the light tones going out to the edge of the paper. While this was all fairly damp (I painted very quickly), I used the painting knife to scrape some thin and thick lights here and there. A fence was suggested near the top of the cliff. This was done to break up the dark shape a bit for visual interest.

C. This is the detail — I added a few brush strokes to the building and to the light shades at the top of the cliff to further suggest a fence and the space between them. I added some very light tones, and while the tones were still wet, I added spatter. Where the spatter went into the wet areas it blurred a bit and where it hit the dry areas, the spots are more crisp. This was simply done for variety. You'll notice some thin vertical dark lines coming down into the dark shapes of the vertical movement from the house down to the bottom of the picture base. These help stiffen the soft areas. Thin brush strokes were put in to suggest tree branches and trunks. A drybrush was used to suggest the mass of small branches and some very small strokes to suggest leaves. A #5 round sable was used for this detail.

A.

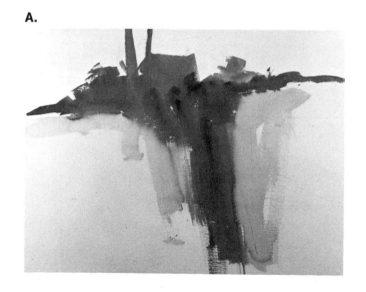

B.

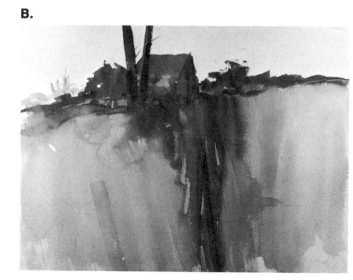

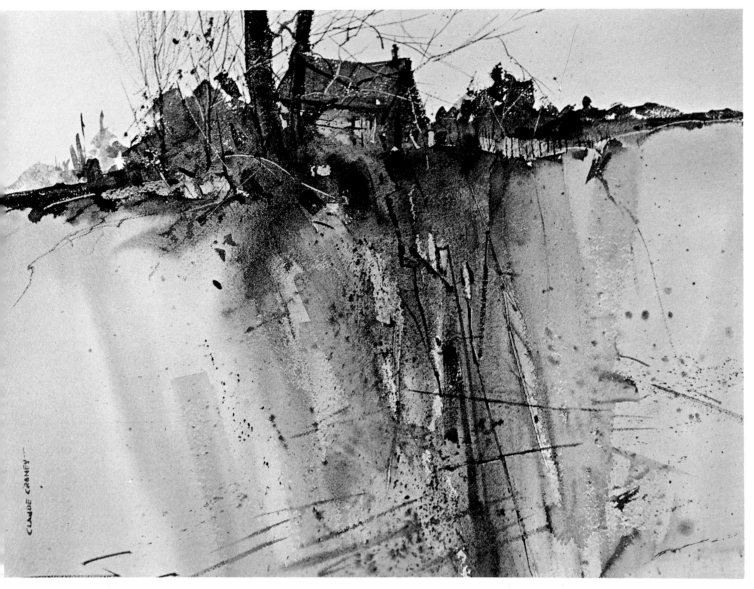

THE QUARRY

C.

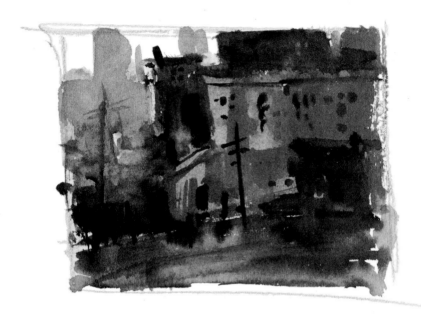

10. 4½″ x 3½″ Here is an example of not having any idea of what I was going to paint. The fact is, there was some dirty color left over on my palette and I had a small piece of scrap paper. My only thought was to do a street scene. So with this fragment of a thought I painted in some shapes, blotted with a tissue and then put in a few accents for window and telephone poles. You'll notice that in this case I left the white paper suggesting the sky in the background. This was all from imagination, which brings me to more comments I wish to make about making small watercolors. First of all, you can do half dozen different subjects in a day, without exhausting yourself or your supplies. The practice will teach you much about the medium. For example, you can experiment to learn when it is best to overpaint a passage for a particular effect, what happens when you blot with tissue, or how you can go back with small brush strokes for accents. You can also use watercolor studies as preliminaries to larger paintings to work out many of your problems before you tackle a larger, more expensive piece of paper. Often you can decide at this point whether it's worth doing a larger version. Small paintings also let you avoid detail and complicated areas. Retaining some of the strong, rich, dark accents and shapes that you can easily get in a small painting usually becomes more difficult in a larger version. Many students tend to start adding water to cover larger areas and of course the water weakens the tone. Consequently, the larger painting may not have the same snap. Try several to begin with — you'll never stop doing them no matter how proficient you eventually become. These little gems never cease to intrigue.

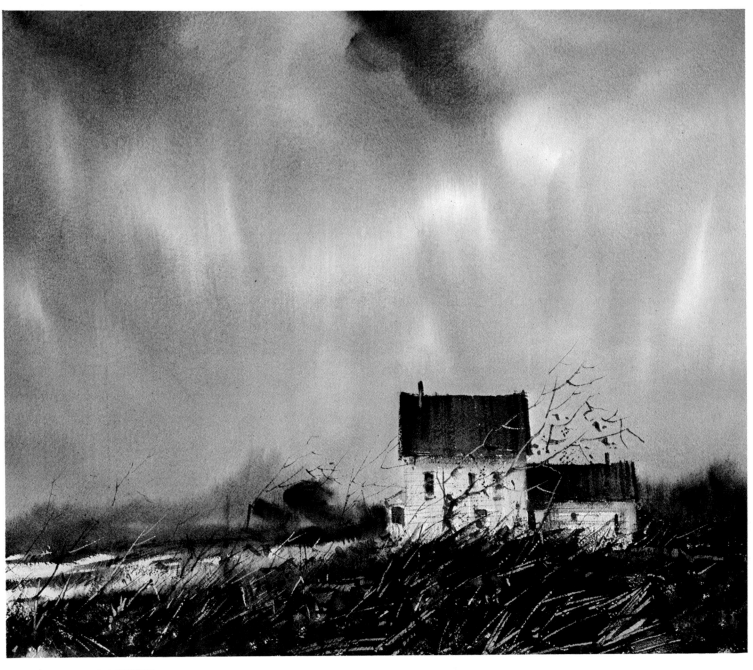

BLEAK HOUSE

11. "Bleak House" 20" x 29" 300 lb. rough D'Arches paper. Much of the strength of this picture is based on the simplicity of its three basic tones — dark, light and middle.

The sky sets the mood here and was painted wet-in-wet. I tilted the drawing board to about a 60 degree slant to allow the paint to run down, creating the controlled "accidental" effect of a rainy day.

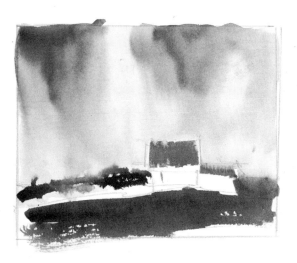

12. "December Snow" 14" x 20" 300 lb. rough D'Arches. This painting was done from memory of an old stone building I regularly pass when I drive along Route 7 between Danbury and Westport. First I decided that the white of the paper would serve as the lightest tone of the snow, therefore, the sky had to be lower in value to emphasize the snow's importance.

A. The first step was to wet the entire sky area. The sky was painted wet-into-wet with some shapes for the background trees and the distant hills. Before the area dried completely,

B. I painted in some darker tones for the trees into it. Then moving swiftly, I painted in the shapes of the building and the dry grass tones. A couple of windows in the building and some light lines in the foreground grass were scraped out with the painting knife while the areas were still damp.

DECEMBER SNOW

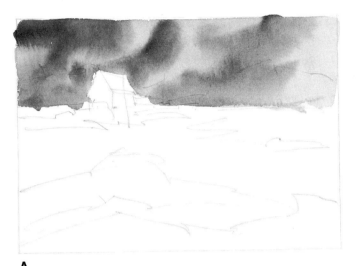

A.

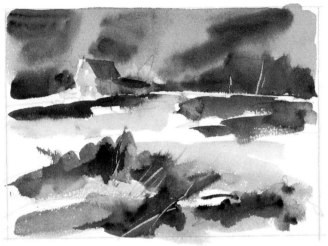

B.

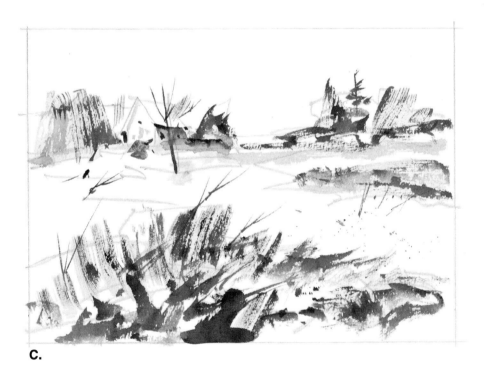

C.

C. Completion of painting. Notice how I've added some bold drybrush over the background trees to build up a bit more texture. I've added a few quickly drawn lines to the buildings. Observe that I added a tone in an area that I thought originally wasn't quite dark enough. The dark lines were painted in along the edge of the roof, then the lighter tone added next to it while it was still wet, creating a soft edge. This also blurs into the dark doorway. There will be times when you add a dark tone here and there for an accent, but you may not want it to have a hard edge. While it is wet you can blur it. Simply wet the edge of this dark tone with a little water on your brush. In the foreground grass I've added some drybrush in a bold manner and some small thin lines to suggest blades of grass. And right across the snow I've added some spatter tone for variety and added texture.

13.

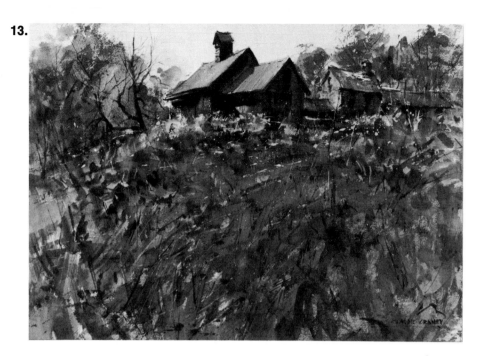

Compare these two paintings done on the same location—proof that there is no one way to paint a subject. These two versions were just painted at different distances from the same subject.

13. "Abandoned Farm" 21″ x 29″ 300 lb. rough D'Arches. In this first one I stood at some distance from the barn and took in much of the surrounding areas and the entire barn in its setting.

14. "Barn Patterns" 21″ x 29″ 300 lb. rough D'Arches. In the second one I moved right in on my subject for a tight close up. Here I became not only interested in the big design and pattern but also the textures of the old wood. In most cases the artist has to simplify, eliminate and suggest. In other words, he paints only part of what he sees. But in the case of a close up he exaggerates the texture and paints almost more than he sees to suggest the nearness of the subject.

Make it a practice to weigh the opposite merits of a distant view vs. the close up. When time allows it's often interesting to do both. For though the subject is the same, the whole mood and approach is different as you discover the special qualities of each view.

14.

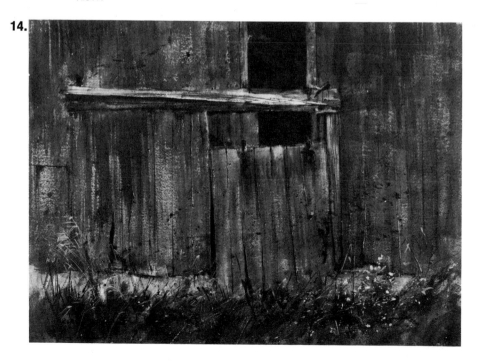

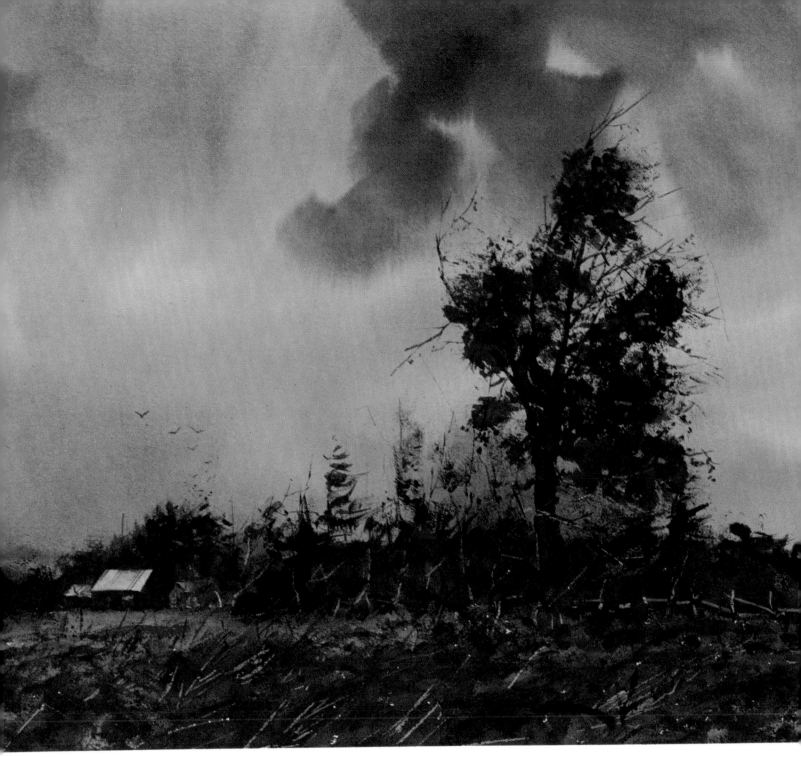

SUMMER STORM

15. "Summer Storm" 21" x 29" rough D'Arches paper. This kind of subject can be developed into almost endless variations of weather, season or time of day. I designed this picture from several small pencil sketches from imagination, working for mood in a low minor key.

Everything has been muted or greyed in color, while retaining a strong three value pattern. The greatest contrasts have been reserved for the barn, which is counterbalanced by the dark silhouetted shape of the tree. I did not attempt to paint in the tree until after the entire sky area was completed and dried.

Many students have problems with such a subject because they try to put the tree in too soon, forcing them to paint the sky tones in around the branches and leaves. This produces a labored look, destroying the desired effect of spontaneity.

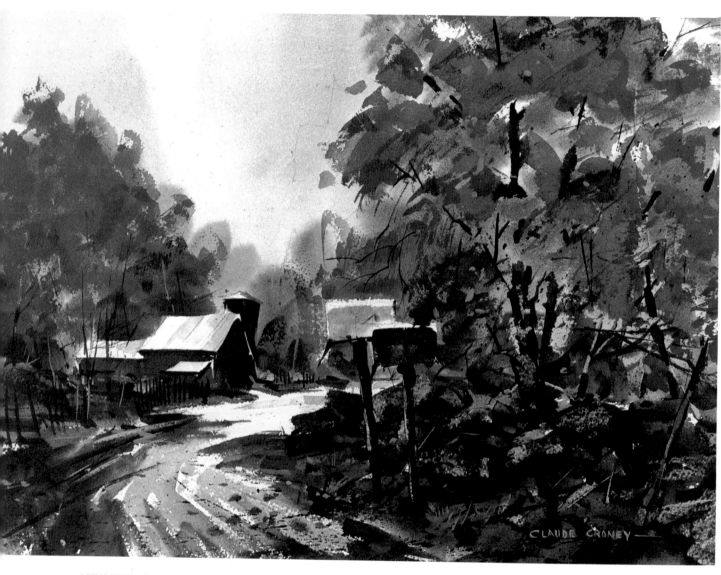

NEW ENGLAND, R.F.D.

Collection of Mr. and Mrs. John J. Frey

ACRYLIC AS WATERCOLOR

ANYONE who paints with watercolor should be aware of the special qualities obtainable with acrylics. Without going into a detailed report of its chemistry, acrylic is a kind of paint which is water based, but which becomes insoluble once the water has dried or evaporated. The paint may be used in thin dilution like a transparent watercolor, applied as a thick impasto similar to oils, or at any consistency in between.

I'm going to talk about the watercolor approach. Although many of the considerations of technique are the same for both acrylic and watercolor, there are several important differences too. I'll list them here and then discuss them in detail as we go along.

1. Acrylic pigments tend to be more fully saturated than watercolors. That is, they are slightly stronger and brighter.

2. Because the pigments become insoluble, or waterproof when dry, successive washes may be applied over dried areas without disturbing the underpainting.

3. Since the underpainting cannot be redissolved, a soft blended edge can be obtained *only* while the paint is first wet.

The picture on the left allowed me to take advantage of the brilliance of acrylic pigments in depicting the Fall coloring. Although the foliage of the trees is made up of a series of superimposed colored washes, the pigment has not become dulled or muddy as would have been the case with regular watercolor. Because the paint is insoluble once dried, there was no intermixing of the pigments and the color has kept its full luminosity.

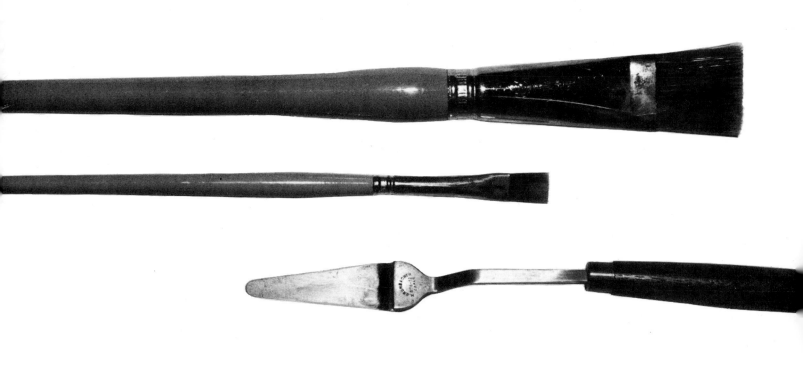

Unless used properly, acrylic paints are hard on brushes. They will dry up in the bristles, particularly in the heel of a brush, even during the painting process if the brush is set aside for a few minutes. This will cause the bristles to spread out and become impossible to bring to a point.

Natural bristles have slightly porous surfaces which the acrylics can cling to. Even prompt rinsing will not remove all of the pigment and any painting session should be followed by a careful washing of the brushes with soap and warm water.

To solve this problem special brushes with nylon bristles have been devised. They are durable and their slick surfaces can be washed off more readily. However, because I use acrylics with the watercolor method only, I use my regular sable brushes.

The best answer is to keep the brushes, either sable or nylon, immersed in water. I use two containers, one for mixing with paints and the other to drop the brushes into while not in use.

A useful aid is an aluminum water container with an attached spiral wire brush holder. This will hold the brushes suspended under water without resting on their points.

Since the acrylic pigments are somewhat thicker and more buttery than transparent watercolors, it is often preferable to mix up any large amount of paint with a palette or painting knife rather than with a brush.

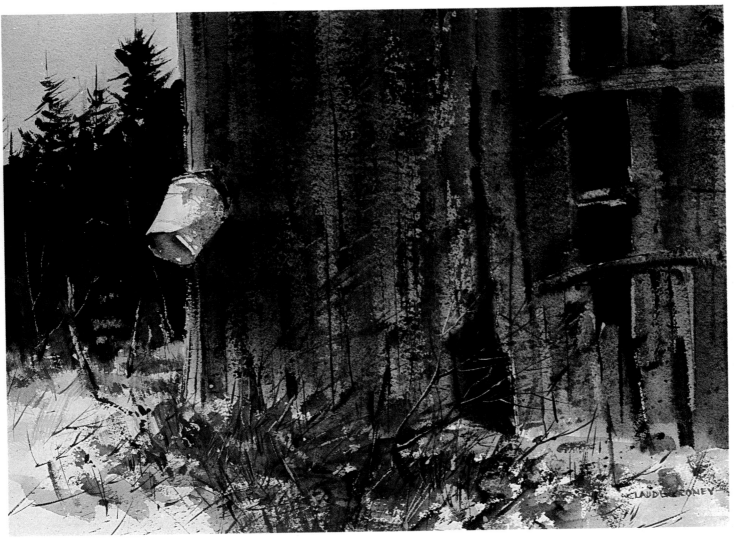

FORGOTTEN

"Forgotten" 14" x 20" 300 lb. rough D'Arches paper. Although indistinguishable from a painting in transparent watercolor, this was done in acrylics. My primary concern in the picture was to capture the textural qualities of the weathered old barn siding.

Reversing my usual procedure I began with a dry-brush rendering of the rough wood surfaces. After it was dried, I was able to add some thin washes of color over the barn without disturbing the underpainting.

As shown in the accompanying diagram, the painting is again a basic, three value scheme. Although the sky, snow and pail are part of the light pattern, I retained some white paper as part of the pail for emphasis to make it the focal point of the picture.

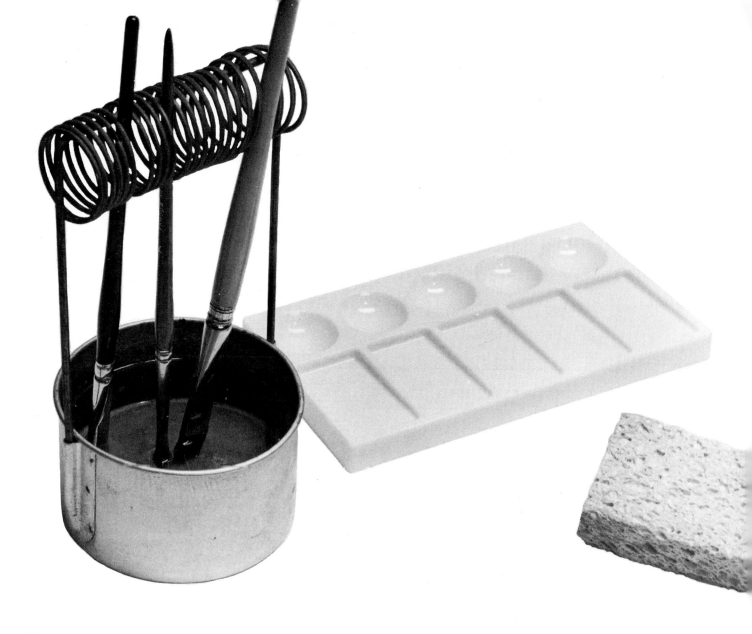

It is a good idea to have your drawing all ready and a color sketch prepared before squeezing out any paint. And, since the paint dries so quickly, it is best to squeeze out only the amount that will be used within fifteen or twenty minutes. This would preclude the usual procedure of setting up a complete palette in the full range of colors.

This brings us to the subject of palettes. Probably a plain piece of plate glass laid over a white cardboard is the simplest and best surface for an acrylic palette. It has the all-important quality of being washable. The paint can't adhere to it and will peel off under water.

Plastic palettes are also washable and have the advantage of well slants that will keep the paints wet longer and also separate the mixtures from each other. A butcher's tray is good too, as are plastic or porcelain cabinet nests. I know of some artists who mix their colors and keep them in covered jars. This however, is more practicable for painters who use acrylics in the opaque oil approach which requires more pigment. One other convenient palette is the disposable one with paper layers, which can simply be torn off and thrown away.

Other items of equipment such as sponges, tissues, razor blades and painting knives are used just as they would be with transparent watercolors.

THE QUARRY

"The Quarry" 15″ x 22″ 300 lb. rough D'Arches paper. Some painters find the problems of blending acrylics so difficult that they avoid using them entirely.

This picture, however, done in acrylics, demonstrates that it is entirely possible to obtain soft edges and blending with the wet-in-wet or wet-next-to-wet technique. The trick is to do it fast, and the *first* time the paint is wet. Unlike transparent watercolors, acrylics once dried cannot be redissolved.

I particularly enjoyed doing this picture which gave me the opportunity to combine a wide variety of accidental and controlled textures and warm and cool colors in the foreground rock wall of the quarry.

COLOR PORTFOLIO

I'VE PURPOSELY avoided writing much about color as such, so we could concentrate on *value* relationships. When you become sensitive to this latter, you will always use color properly.

To demonstrate this fact more forcibly, I have asked permission from nine of my colleagues to reproduce their paintings in this section.

Each picture has been done in a water-based medium, but the subject matter and color schemes are widely divergent. Alongside the reproduction, I've done a small diagram analyzing the value pattern. I believe you will be impressed, as I was, with how closely each artist has followed the three value approach. As you study them it should help you to develop a faculty for analyzing the value pattern of *any* artist's work and more important, to plan your own pictures with more assurance.

YOUNG AND OLD *by* ALEXANDER ROSS
Notice as diagrammed, how the darks are tied together for a strong, unified value pattern.

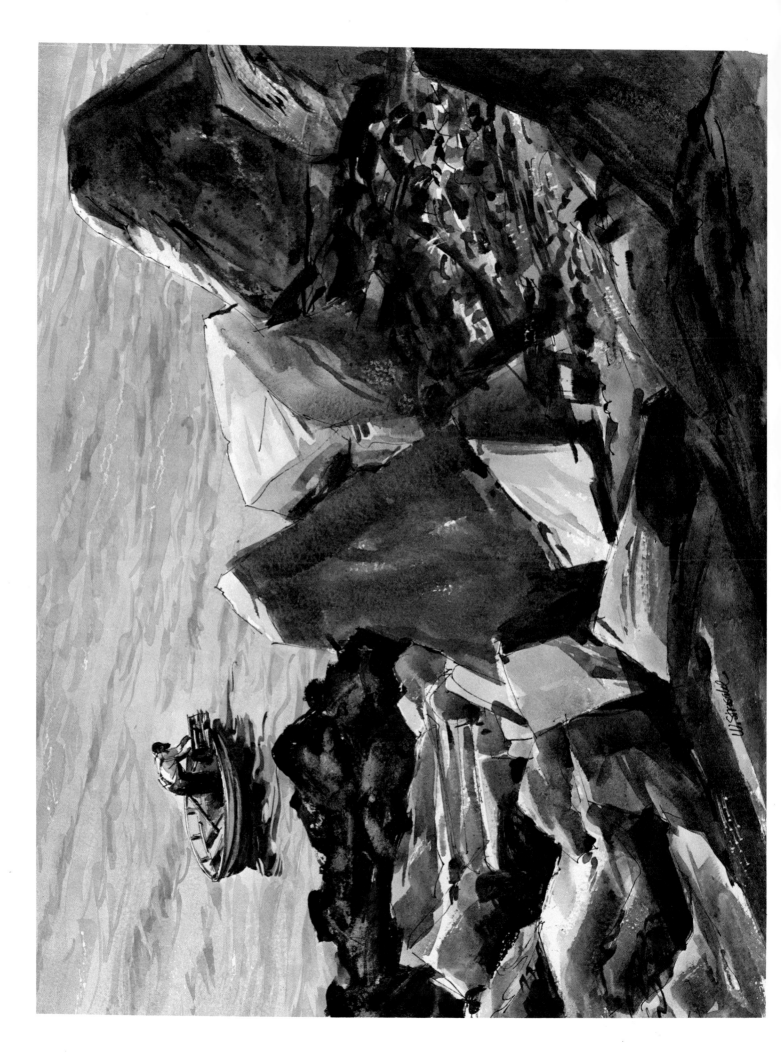

THE LAST TRAP by WILLIAM STROSAHL
Here the pattern of lights is broken up by the rocks which creates a sparkling jewel-like effect.

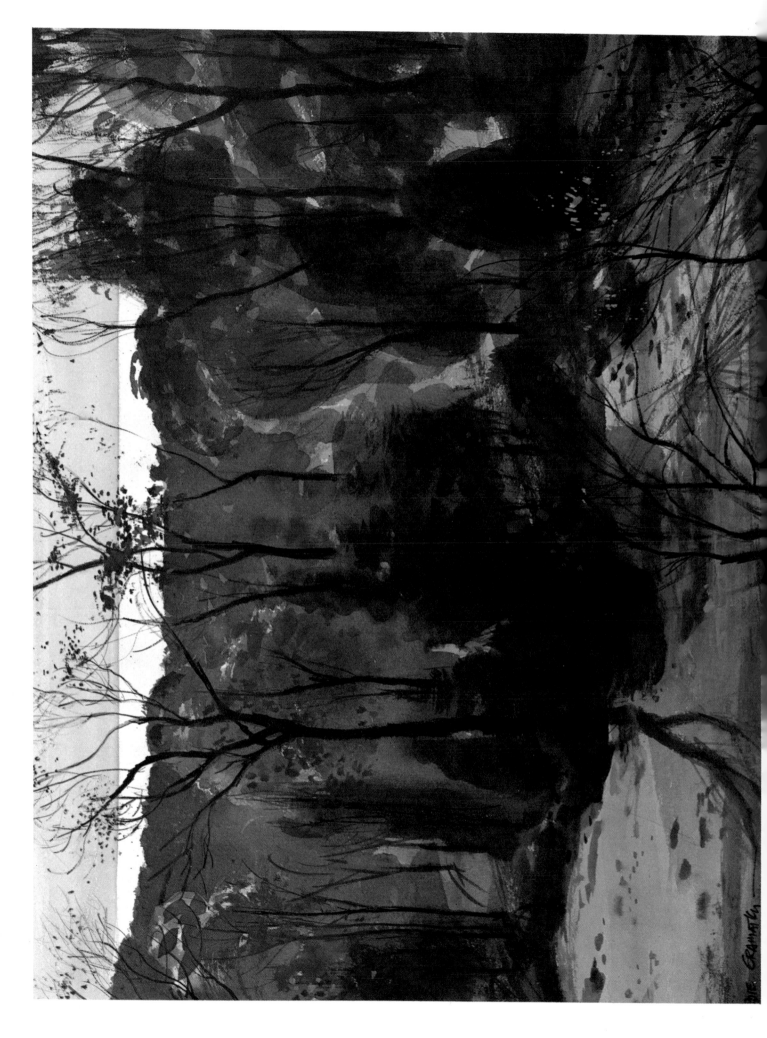

NOCTURNE by HARDIE GRAMATKY
The extra large mass of darks helps to emphasize the light at the top in an unusual and dramatic way.

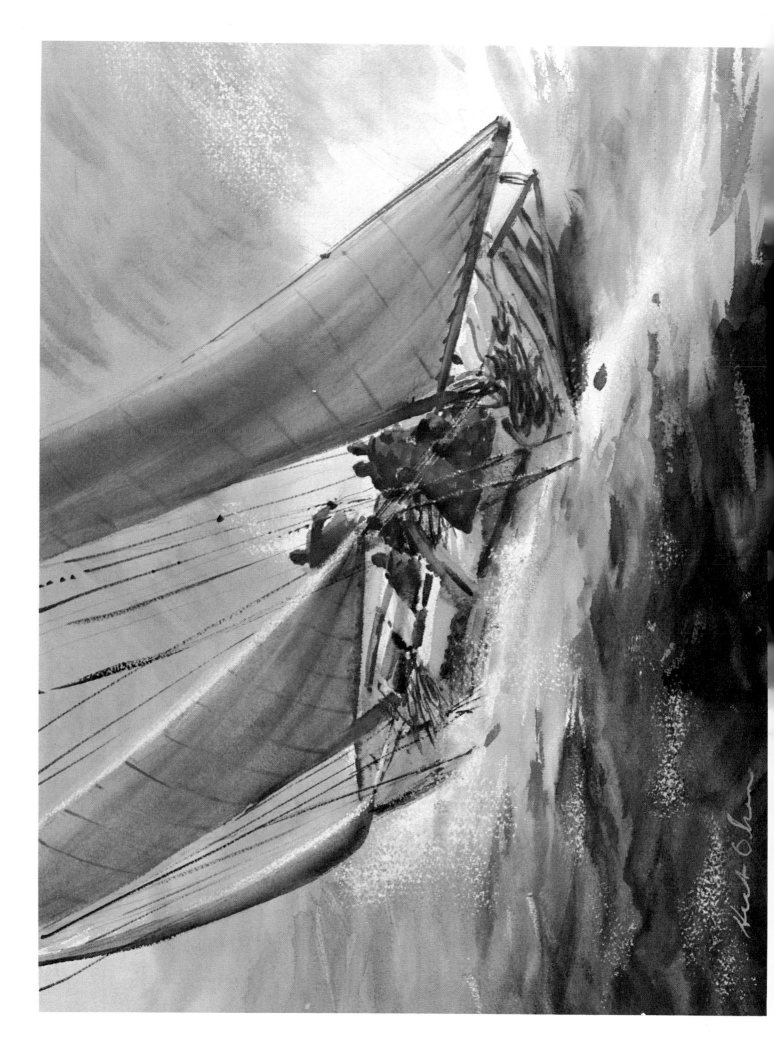

THE CRUISE by HERB OLSEN
In this high-keyed picture, darks in the foreground help to balance the darks in the boat and at the same time play up the white spray.

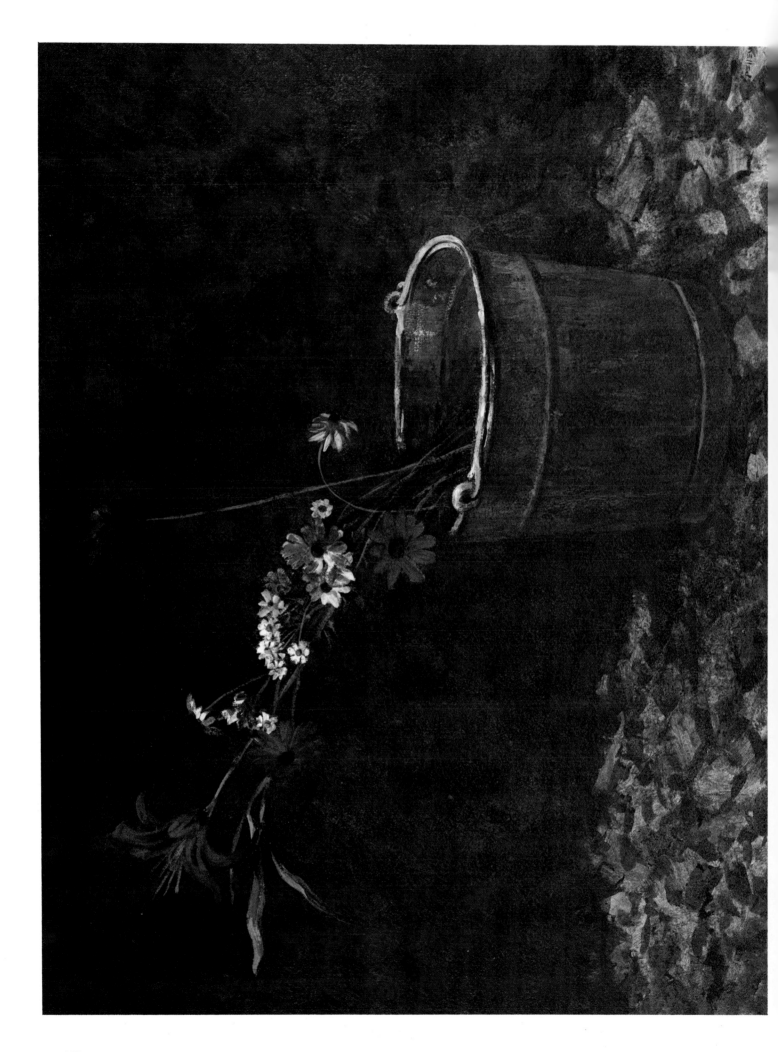

MIXED FLOWERS by JOHN PELLEW
It is interesting to see here how delicately the light values are balanced against the dark, and yet how strong the composition is in spite of its fragile center of interest.

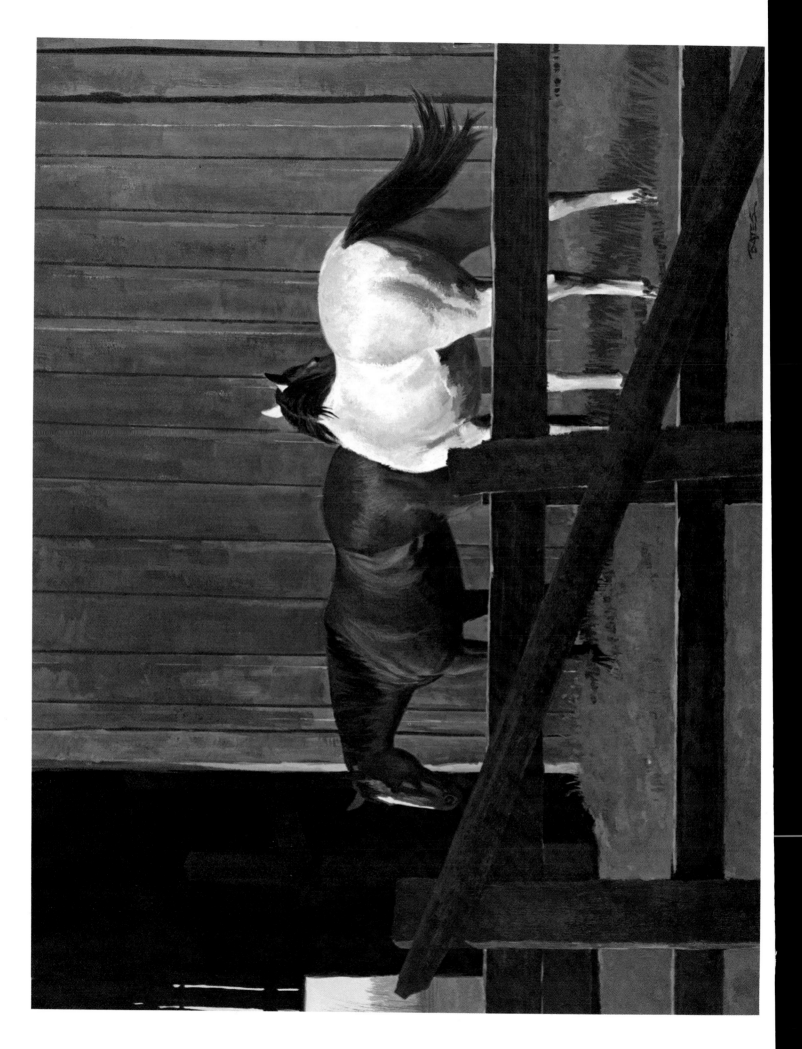

104

WARMING SUN by SAM BATES
This painting illustrates the supreme importance of values. One horse is almost lost against the matching value of the background barn while the other, through contrast, becomes the most important element in the picture.

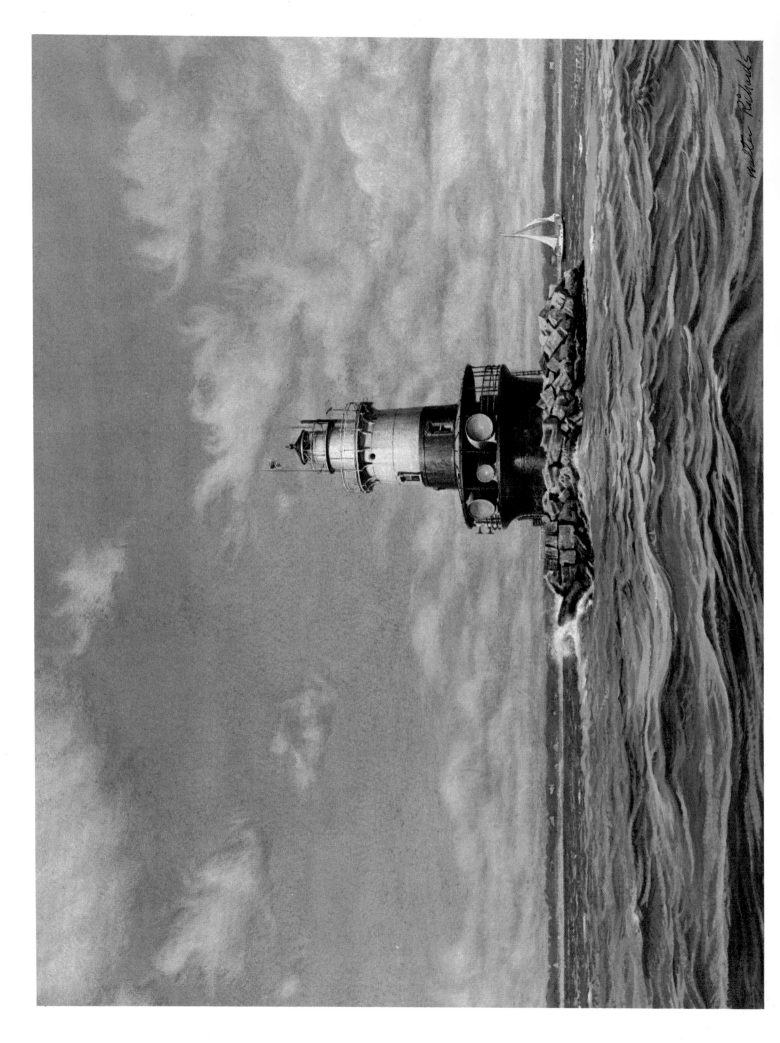

SENTINEL by WALTER RICHARDS
Here is an extremely simple, yet strong composition. There is no mistaking, by size, location, color or value contrast that the lighthouse is the picture's center of interest.

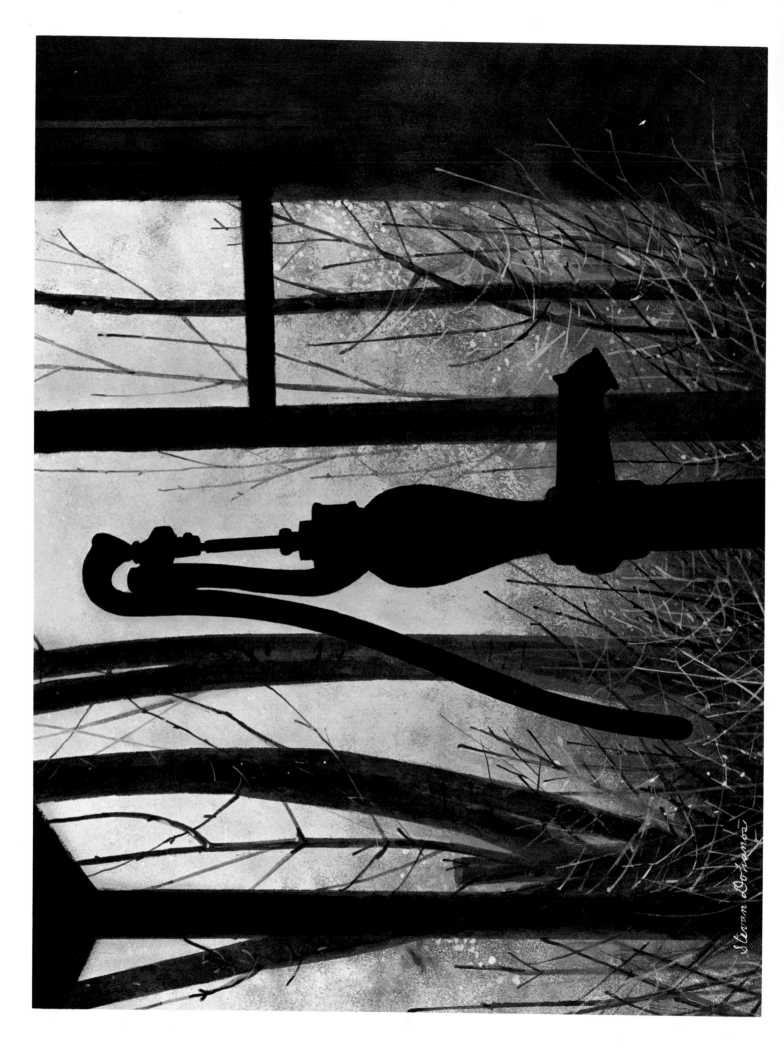

OLD PUMP by STEVAN DOHANOS

The artist has taken an unusual point of view of his subject from within a darkened foreground shed and the pump in silhouette is seen without detail, only as shape. Yet, it is the darkest value and therefore has the strongest contrast against the light background making it the focal center.

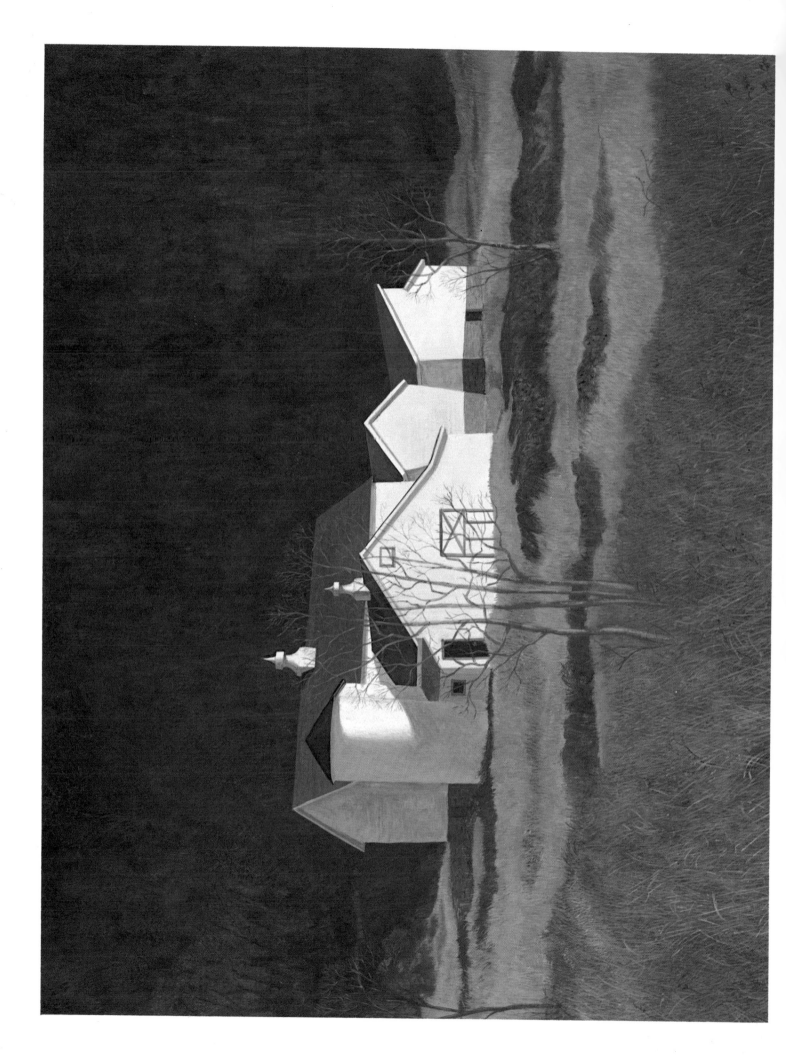

NOVEMBER AFTERNOON
by ALPHONSE RADOMSKI
*This picture pattern is basically a light against dark.
Notice the few dark vertical trees which counter
the strong horizontal shapes and at the same time
serve to tie some of the darks at the top and bottom
of the picture together.*

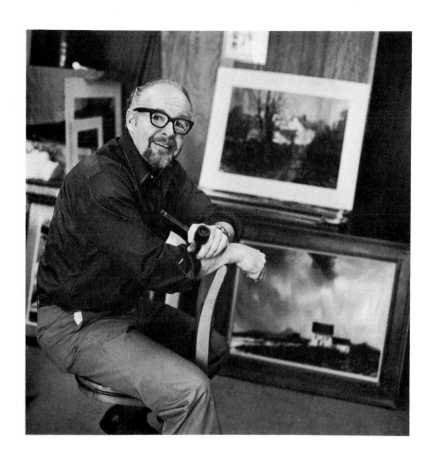

SUMMING UP

THE MAJOR aims of this book have been to show you how to "see" your subject and to translate it via the three value system.

I advise that you get into the habit of first solving any new picture composition with a simple value pattern — then try a couple of different color schemes that *look different* because of their hue — but do not stray in value. Your personal sense of color will take over but it will always be properly *tuned*.

Once you understand and master the three value approach, you will be ready to set forth on your career as a watercolorist. How proficient you become will depend on your perseverance and your talent.

Let me caution you with a few "don'ts":

1. Don't be discouraged if your first few efforts go awry.

2. Don't stop at the suggestions I've made — investigate — invent — experiment.

3. Don't accept the obvious — try to make all your pictures contain some look of you — some viewpoint — some individual touch.

4. Don't be so satisfied with everything you do that you cease to be critical and demanding of yourself.

5. And lastly, *don't* stop painting and thinking and drawing pictures!